IMAGES
of America

WEST PHILADELPHIA
UNIVERSITY CITY TO 52ND STREET

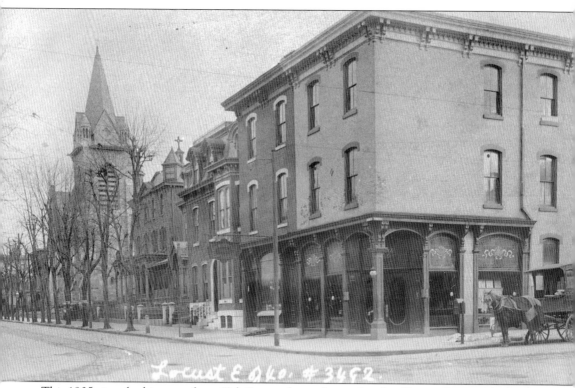

Locust E 940. #3452

This 1905 view, looking east from 40th Street, shows the south side of Locust Street. The horse and cart making a delivery was from John Wanamaker's Department Store. Most of the houses seen here date from the 1860s and 1870s. On Christmas day 1873, the first service was held in the new church building of St. Mary's, the tower of which is seen in the middle of the block. Once a rural church in the midst of a cedar clearing, St. Mary's soon became a city church as West Philadelphia expanded.

IMAGES
of America
WEST PHILADELPHIA
UNIVERSITY CITY TO 52ND STREET

Robert Morris Skaler

ARCADIA

First published 2002
Reprinted 2002, 2003, 2004

Published by Arcadia Publishing,
Charleston SC, Chicago IL, Portsmouth NH, San Francisco CA

Printed in Great Britain

Library of Congress Catalog Card Number: 2001095853

For all general information, contact Arcadia Publishing:
Telephone 843-853-2070
Fax 843-853-0044
E-mail sales@arcadiapublishing.com
For customer service and orders:
Toll-free 1-888-313-2665

Visit us on the Internet at www.arcadiapublishing.com

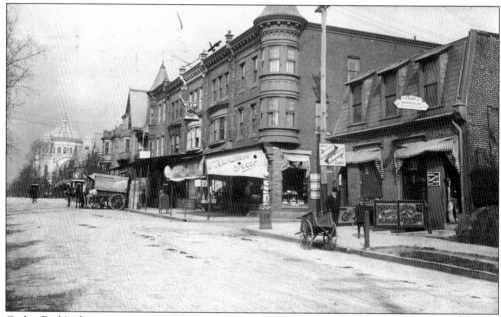

Cedar Park's shopping area at 47th Street, north of Kinsessing Avenue, is seen here in 1910. Fixed metal awnings over the sidewalk were common then, as they provided a loading dock for the wagons and advertising space. A few blocks up (at 47th Street and Springfield Avenue) is the magnificent Byzantine domed St. Francis De Sales Roman Catholic Church, built in 1906 and designed by architect Henry Dagit.

CONTENTS

PREFACE

My interest in Victorian architecture started with my childhood home in the Belmont section of West Philadelphia. My father owned a kosher butcher shop at 871 North 40th Street, and the family lived over the store. My parents, Louis and Minnie Skaler, moved there soon after they were married in 1925, and I was born in that house, the youngest of three sons.

In the early 1940s, as a youngster on my way to school, I would walk along tree-lined Preston Street past blocks of old Victorian houses. Their peeling paint reminded me of faded roses dropping their pedals as they stood sadly behind rusting wrought-iron fences. The ornate architecture of these once grand villas fascinated me, and I often wondered how did they look when they were new. Years later, I found that collecting old postcard views of West Philadelphia would answer my childhood question.

My parents told me that the Great Depression devastated West Philadelphia's middle class. A foreclosed house in Belmont could be purchased for as little as $400 and were often bought by real-estate speculators. The need for cheap housing became acute after World War II. By the 1950s, Belmont was beginning to look shabby and worn, like a stage set from *Death of a Salesman*. In 1952, my parents decided to move to Northeast Philadelphia, where they opened a new butcher shop. I studied architecture at the University of Pennsylvania in the 1950s, at a time when Victorian architecture was considered an aberration. Victorian architecture is no longer thought of as an aberration, and some West Philadelphia Victorian neighborhoods are being lovingly restored by new homeowners. However, other neighborhoods, such as Belmont, have been less fortunate.

Thomas Wolfe wrote, "You can't go home again." Sadly, for many former West Philadelphians, this is true. Some neighborhoods featured in this book have deteriorated, have been demolished, or have been replaced by ill-conceived urban renewal projects. It is my sincere wish that these historical images might make it possible, in some small way, for West Philadelphians to go home again.

—Robert Morris Skaler

INTRODUCTION

In the first half of the 19th century, West Philadelphia was farmland and virgin stands of timber connected by a wooden covered bridge at Market Street and by a floating bridge at Grays Ferry to Quaker City. The area had large country estates, such as Woodland and Busti's Blockley Retreat Farm. Old Lancaster Pike and Darby Road started their journeys from the Market Street Bridge. Colonial inns on these roads catered to the stagecoach travelers who made the 65-mile trip from Lancaster to Philadelphia in a remarkable 12 hours on America's first turnpike. A permanent bridge was built at Market Street in 1805. By 1810, the population of the West Philadelphia had doubled. As the 19th century progressed, the name West Philadelphia came into common usage for the entire area, which included the villages of Mantua, Powelton Village, Kinsessing, Belmont, Paschallville, Hamilton Village, and Hestonville. In 1854, all these areas were incorporated into the city of Philadelphia.

Because early-19th-century West Philadelphia was rural and remote with cheap land, it soon became evident to the city fathers that it would be a great place to put the city's charitable institutions and to remove the pauper class, the insane, and the sickly from Center City. In 1832, therefore, the City of Philadelphia purchased 187 acres of the Woodland estate from William Hamilton's heirs and built a large almshouse, known as Blockley, with a city charity hospital attached (later known as Philadelphia Hospital). The almshouse was located on lowland near the river and had an average daily population of some 4,000 inmates.

In 1836, the Pennsylvania Hospital purchased the Busti estate, which ran from 42nd Street to 49th Street and from Market Street to Haverford Avenue. A building for the care of the mentally ill was erected, and the Busti mansion was occupied by its progressive superintendent, Dr. Thomas S. Kirkbride.

By the end of the 19th century, if one was incurable, insane, consumptive, blind, orphaned, crippled, destitute, or senile, one would most likely end up in a faith-based charitable institution or asylum somewhere in West Philadelphia, beyond the pale.

The coming of the railroad did much to accelerate the growth of West Philadelphia. In 1864, the Pennsylvania Railroad erected a station at 30th and Market Streets, a principal depot. (In those days, the trains did not go directly into the city.) This station was abandoned when a larger one was built at 32nd Street in 1876 to accommodate the crowds coming to visit the Philadelphia Centennial Exposition. After 1881, the trains began to run on top of what was nicknamed the "Chinese Wall" into the new Broad Street Station of Pennsylvania Railroad, opposite City Hall. As result, the West Philadelphia terminal's importance declined. With the

opening of the 30th Street Station in 1934, West Philadelphia was again an important passenger destination.

Also significantly contributing to West Philadelphia's growth were the horsecar lines that made local stops. Prior to 1860, there was no regular passenger railway existing on Market Street, and even after that date, the cars only ran as far west as 41st Street. The Market Street line ended at a large passenger depot at 41st and Haverford Avenue.

The area called University City today began to develop with a rush after the Civil War with the opening in 1866 of the Chestnut Street Bridge. Chestnut Street, which heretofore had been little more than a dirt road, was graded and improved. By 1872, the Philadelphia City Horse Car Passenger Railway had a line (green car, white lights) that ran from 22nd and Chestnut Streets across the bridge to 41st and Chestnut Streets, where the terminal stables stood. In 1883, this terminal was destroyed by fire. It was rebuilt and used as trolley terminal until the 1940s.

Another force that accelerated early residential development in West Philadelphia was the establishment of the University of Pennsylvania and the Presbyterian Hospital—institutions that were important in the growth of the area now called University City. In 1870, the trustees of the university decided to remove the rapidly expanding University of Pennsylvania from its location in old Philadelphia. The trustees purchased the 101-acre Blockley estate in West Philadelphia, and the cornerstone for the first building was laid in June 1871. Additional buildings were erected during ensuing years. By 1900, the university and hospital covered 27 acres. In addition, in 1871, the Presbyterian Hospital started to build on the site of Dr. Courtland Saunder's mansion, located on an entire city square from Powelton Avenue to Filbert Street and from Saunders Avenue to 39th Street.

The Philadelphia Centennial Exposition of 1876 also did much to hasten the development of West Philadelphia. More than 10 million people went to the exposition. In one of the centennial guidebooks, West Philadelphia is described as "one of the most attractive sections of the city, blending as it does, the beauties of both country and town. It is a location much sought after for private residences and consequently is filled with handsome edifices and delightful villas." Hundreds of thousands saw the advantages of living in West Philadelphia as they traveled to the exposition. The area soon became home to wealthy businessmen who built elegant mansions and villas in Powelton Village and University City. After the exposition, West Philadelphia's growth also accelerated northward into Belmont, Parkside-Girard, and westward into Cedar Park, Spruce Hill, and Walnut Hill in the 1890s with the introduction of electric trolley lines.

After the Market Street Elevated opened in 1907, what was once open farmland developed rapidly with modest row houses with West Philadelphia's signature front porch and garden, electricity, and indoor plumbing, resulting in Philadelphia receiving the national reputation as the "City of Homes."

In 1900, the majority of the new West Philadelphia homeowners were white Protestants and Catholics. At that time, the dominant religious denominations were Baptist, Methodist Episcopal, Protestant Episcopal, Lutheran, Presbyterian, and Roman Catholic. There were several Friends meetinghouses, Disciples of Christ churches, and a Hebrew congregation (in Paschallville at 69th and Paschall Avenue). We also know that there were Afro-Americans living in West Philadelphia from the churches they established there. One African Methodist Episcopal (AME) church, Mount Pisgah, was located at 40th and Locust Streets. Two Baptist (African American) churches, Monumental and Providence, were located at 41st and Ludlow Streets and 37th and Filbert Streets, respectively. One AME Zion church, St. Matthew's, was located at 58th and Vine Streets.

If you had a West Philadelphia address on your calling card in 1900, would you be accepted by the old Philadelphia elite ensconced in Center City? Not if your West Philadelphia address was "north of Market Street."

The phrase "north of Market Street" had great significance to old Philadelphia society. In a book entitled *North of Market Street, Being the Adventures of a New York Woman in Philadelphia*, published in 1896, the snobbish aunt advises her young niece,

> Nice people, here in Philadelphia [Center City], are those whose grandfathers were south of Market Street. "But how about West Philadelphia? That seems to me a beautiful part of the city, so open and breezy and with such pretty houses and fine shade trees," the young lady asked her aunt. Her aunt answered, "Oh, West Philadelphia is divided also: North is of course the Great Taboo. South is blue if you have piles of money: if not it is not black and not blue, but a beautiful bluish grey."

As absurd as this seems today, in the 19th century having a "north" address on your calling card lowered your status with Philadelphia society. Although Powelton and Belmont had some of the most beautiful mansions and churches, its residents were still considered socially nouveau riche, or "north of Market." Those with "piles of money" knew the social code and built their mansions in a narrow strip between Market and Pine Street.

Perhaps to overcome this social prejudice, the late-19th-century meritocracy that made Powelton their home was more extravagant in the design of their homes than those built by the old Philadelphia elite in Center City. They built their homes large and high above the street in order to enhance their display of wealth. Their architects, who were not patronized by fashionable Philadelphia society, knew what the wealthy railroad executives, manufacturers, and distillers wanted. They designed their houses accordingly, as a testament to their owner's wealth.

Fortunately for historians, an accurate pictorial history of the gilded age of West Philadelphia's development was documented in the golden age of postcards. From 1904 to 1911, hundreds of real photo postcards of street scenes were made by Mercantile Studio in West Philadelphia. Not every street was photographed by Mercantile Studio, but careful consideration and organization has been used in selecting images that best illustrate West Philadelphia's development.

In these pages, we will travel the streets of the historic West Philadelphia as it was 100 years ago. We will travel west from the Schuylkill River to University City, Spruce Hill, Walnut Hill, and Cedar Park and then turn north to the neighborhoods of Powelton, Belmont, and Parkside-Girard. As we progress, we will also be traveling in time from the post–Civil War era to the 1876 centennial, through the newly electrified 1890s, and finally ending at the turn of the century, when these areas of West Philadelphia were fully developed.

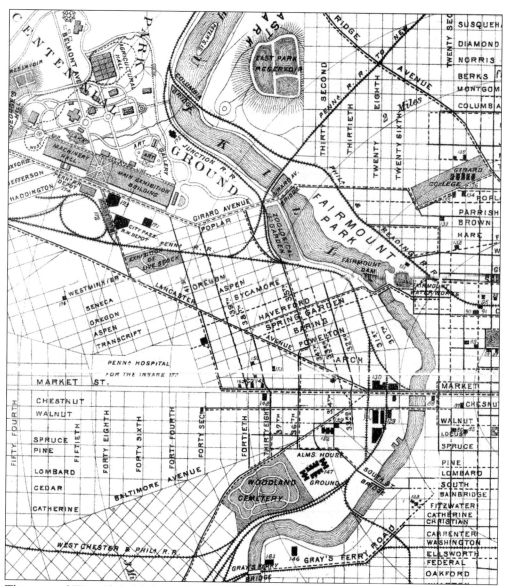

This map of West Philadelphia is from *Philadelphia and Its Environs,* a guidebook published by J.J. Lippincott & Company in Philadelphia for visitors to the 1876 Philadelphia Centennial Exposition. The dotted lines on the map represent horsecar trolley lines. In 1876, there were no lines farther west than 42nd Street in what is now University City. For the exposition, the horsecar trolley companies extended their tracks north to the centennial grounds in West Fairmount Park. At that time, many neighborhoods of West Philadelphia still had had the appearance of suburban villages. As visitors traveled to the exposition, they had a good view of these undeveloped areas of West Philadelphia, and they liked what they saw. Consequently, the neighborhoods of Belmont, Powelton, Mantua, and Parkside-Girard were soon built-up with typical West Philadelphia row houses less than 25 years after the exposition closed.

One

UNIVERSITY CITY

The name University City was fabricated in the 1970s by a local real-estate salesman to distinguish the area from the rest of West Philadelphia. It was also descriptive of the area into which the University of Pennsylvania was then rapidly expanding, from the Schuylkill River west past 40th Street, and north almost to Market Street.

In the 19th century, the area of University City south of Woodland Avenue was called Blockley. It was one of the first areas developed west of the Schuylkill River. The Blockley Almshouse once stood where Civic Center Boulevard is today. From 1860 to 1910, many prosperous Philadelphians built their palatial homes in socially correct University City. They included one of the nation's great financiers, Anthony J. Drexel, founder of the Drexel Institute; Charles Mosley Swain, founder of the *Philadelphia Record*; financier Clarence H. Clark; noted philanthropist Samuel Fels; and cigar manufacturer Otto Eisenhlohr. The Fels and Eisenhlohr houses, now owned by the University of Pennsylvania, are still standing.

At the turn of the century, University City was jokingly described as being "an integrated neighborhood, Protestant and Episcopalian." In 1900, 94.5 percent of its inhabitants were white, about the same percentage as found in all of Philadelphia at that time. Only 17 percent of the area's residents were foreign born, and of them almost two thirds were from Ireland. University City historian Ruth Molloy attributes the high percentage of Irish immigrants to the fact that the Irish were employed as the domestic help in the big houses. All the great mansions, and even the row houses, were built with servants' stairs. Wages for domestic help were low, and it was very common for the upper and middle classes to have many servants to deal with the everyday drudgery of running a Victorian household as well as caring for their large families.

As one walks or drives through University City today, with its new construction activity, impersonal modern garages and the failures of modern architecture, it is hard to imagine what this area was like 100 years ago. Between the new construction sites, however, one might find glimpses into the area's past—a great church, a millionaire's mansion, or a once fashionable apartment house.

Imagine 39th and Chestnut Streets on a Sunday afternoon a century ago. Four large churches, within blocks of one another, have just ended Sunday services; church bells are ringing; and the sidewalks are full of ladies and gentlemen in their Sunday best, promenading past wrought-iron-fenced gardens and elegant villas. Gentlemen tip their top hats as they greet fellow churchgoers. The new Chestnut Street electric streetcar clangs its bell as it approaches, and horse-drawn open carriages drive up and down the street. This is University City at the beginning of the 20th century, in its gilded age.

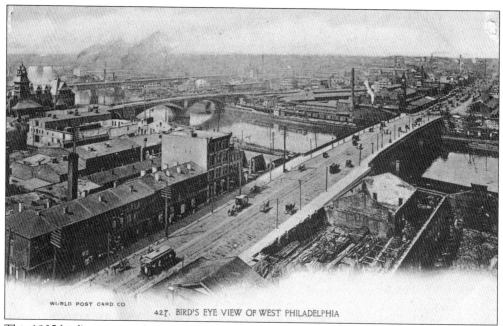

This 1905 bird's-eye view, looking west, shows how heavily industrialized the west bank of the Schuylkill River was at that time. In the foreground is the Market Street Bridge. On the south side of 30th and Market Streets was a huge wholesale market and stockyards. On the north side was the former Pennsylvania Railroad 30th Street Station.

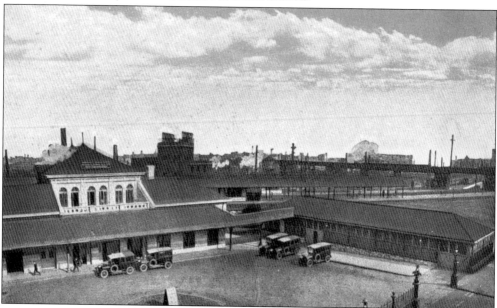

At the time of the 1876 Philadelphia Centennial Exposition, the original station at 30th and Market Streets was the busiest train station in Philadelphia. In 1901, the Pennsylvania Railroad's West Philadelphia station was relocated to 32nd and Market Streets. This postcard view of the station at 32nd Street was made in 1907. The new station was designed by the architectural firm of Furness, Evans and Company, which designed most of the Pennsylvania Railroad's local stations.

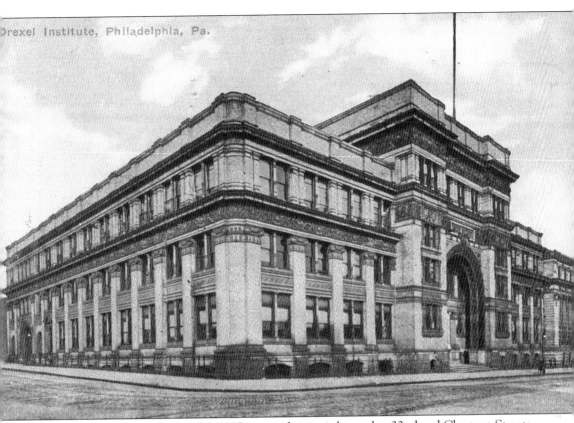

The Drexel Institute, seen in this 1907 postcard view, is located at 32nd and Chestnut Streets. Built in 1891, it was designed by architect Joseph Wilson and founded by philanthropist and banker Anthony J. Drexel. A Philadelphia guidebook incorrectly states that the site was chosen because Drexel would meet his friend George W. Childs "at the corner every morning for their walk into town." The site was chosen because it was easily accessible to the working class, whom Drexel wanted to educate. However, Drexel did in fact walk from his mansion at 39th and Walnut Street, across the Walnut Street Bridge to 22nd and Walnut Streets, where his friend George Childs lived in a white-marble mansion. The two friends would then walk together to the Public Ledger Building at 6th and Chestnut Streets, where Childs would enter his office and Drexel would continue on to the Drexel Building at Fifth and Chestnut Streets. Year in and year out, they walked the same round, making themselves well-known personalities in their time.

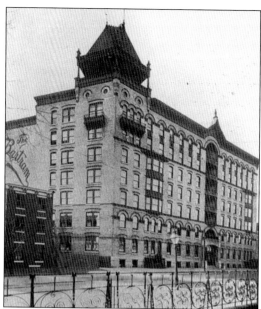

The Bartram apartment building was located on the 3300 block of Chestnut Street and extended through to Woodland Avenue. It was built in 1893 for developer Adolph Segal. Shown here in a photograph from the *Office Building Directory* of 1899, it was one of the first high-rise apartment buildings built in West Philadelphia. The Bartram was designed by architect William H. Free, whose residential architectural designs are not very noteworthy.

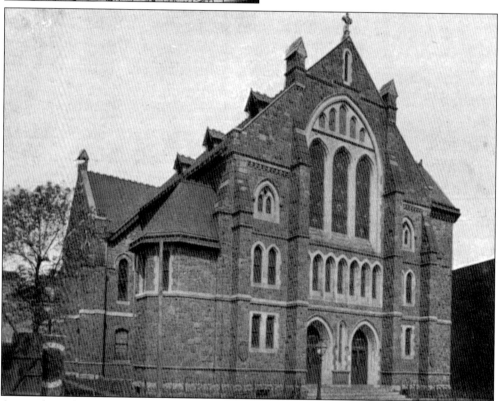

Across from the Bartram was the Asbury Methodist Episcopal Church, in the middle of the 3300 block of Chestnut Street. It was built for $80,000 (including the cost of the land) in 1883. The architect was John Ord. Asbury Church was named for Bishop Francis Asbury and was regarded as the "mother church of West Philadelphia Methodism." Unfortunately, this church was destroyed by disastrous fire on March 9, 1997.

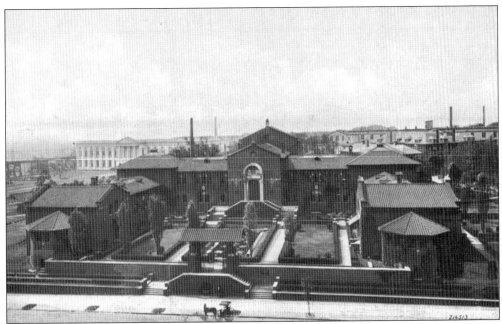

The University Museum, located at 33rd and Spruce Streets, was built in 1899 and was designed by a team of prominent Philadelphia architects—Wilson Eyre, Cope and Stewardson, and Frank Miles Day. This 1907 postcard shows the museum without its great rotunda, which was built in 1915. On the left is the white-pillared Commercial Museum. On the right is Philadelphia General Hospital, formerly Blockley Asylum.

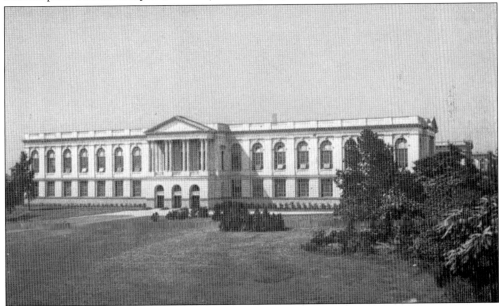

The Commercial Museum of Philadelphia is shown here in a beautiful 1907 postcard printed by the Detroit Publishing Company. Founded at the close of the Chicago Exposition in 1894, the museum's four elegant classical buildings constituted a great permanent international trade exposition. Philadelphia was known then as the "workshop to the world," and the city actively sought international trade through its Foreign Trade Bureau, housed in the museum.

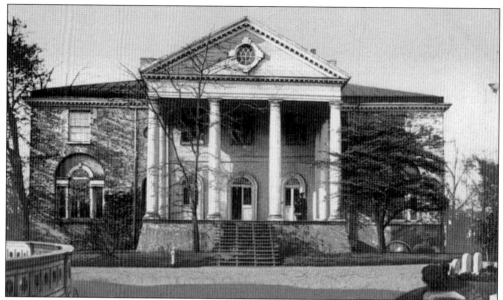

Woodland mansion is one of the finest examples of Federal-style architecture and one of the first American houses to have a freestanding projecting portico. The Woodland estate, located near 40th and Woodland Avenue, was the home of Andrew Hamilton, lawyer and designer of the statehouse (Independence Hall). The property was sold to Woodlands Cemetery in 1843. This beautiful postcard was published in 1905.

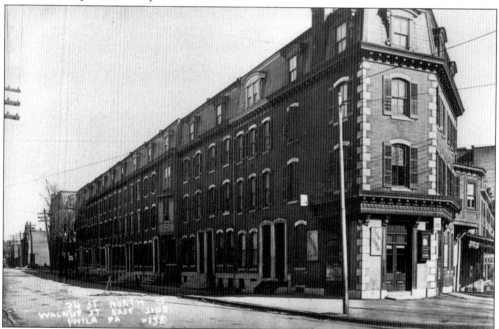

Where 34th Street and Woodland Avenue intersect stood this mansard-roofed row of houses, already standing in 1872. The stores shown on the right faced Woodland Avenue. The corner-store signs read, "Confectionery," "Bell Telephone," and "Light Lunch." This 1907 real photo postcard view, looking north from Walnut Street, shows the east side of 34th Street. (Courtesy Howard Watson.)

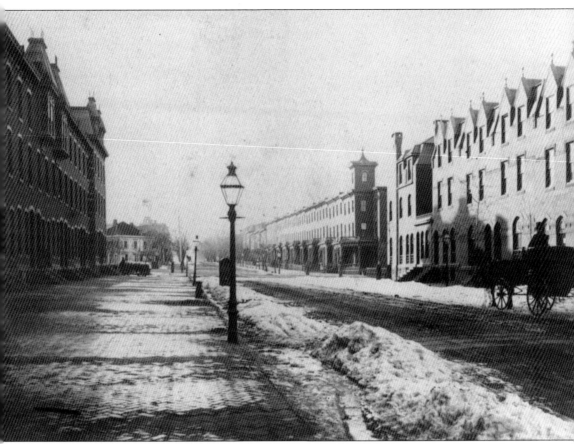

The horse-drawn carriage in this 1883 photograph is shown traveling west on Walnut Street toward 34th Street at a time when there were no electric streetcars or telephone poles. This was University City in the "age of innocence," when it was called West Philadelphia. The south side of the 3300 block, on the left, was one of the first acquisitions of land on Walnut Street by the University of Pennsylvania. In later years, except for the law school (built in 1900), campus expansion would remain south of Walnut Street. By the 1960s, however, the university was rapidly expanding (south, north, and west), closing off part of Woodland Avenue and Locust Street to traffic and eventually expanding west to 40th Street. (Courtesy the University of Pennsylvania Archives.)

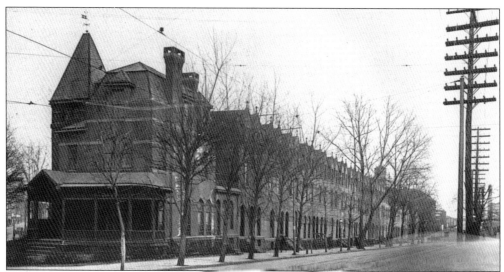

The colonic-style house and the long row of houses shown in this 1907 postcard were built in the late 1870s. It is the north side of the 3300 block of Walnut Street, with Woodland Avenue on the far right. Walnut Street now has telephone poles and electric streetcars. As early as 1890, the University of Pennsylvania was acquiring houses on the south side of this block of Walnut Street. (Courtesy Howard Watson.)

Located at the northern edge of the University of Pennsylvania campus was this row of houses, built c. 1870 at 34th and Walnut Streets. This 1907 view shows the College Pharmacy, located on the northwest corner of the block, as the only commercial establishment. Over the years, as the university expanded and the students' demand for services increased, this block became entirely commercial with shops and restaurants. (Courtesy Howard Watson.)

Looking north on 34th Street, this 1907 view shows the College Pharmacy and the new law school building. Behind the College Pharmacy, between Moravian and Samson Streets, is a row of four large houses built in the 1870s. They were converted to a women's dormitory c. 1910 and were later renamed Potter Hall.

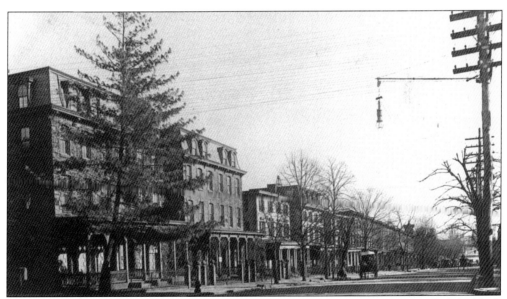

This 1907 view looks east on Walnut Street from 36th Street. On the western end of the block (foreground), the row of earlier Italianate-style houses has given way to four-story twins in the Second Empire style, a style that was popular right after the Civil War. As one moves west in University City, the houses become grander, architect-designed, and fewer per block. (Courtesy Howard Watson.)

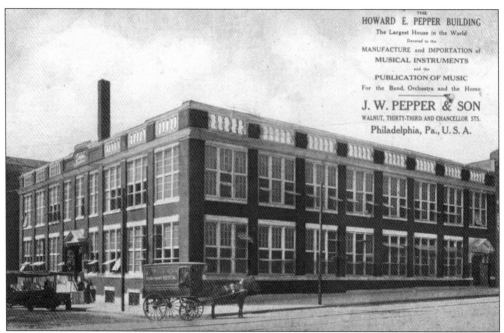

This *c.* 1912 advertisement postcard features the new Howard E. Pepper Building, located on the southeast corner of 33rd and Walnut Streets. The card says that it is the "Largest House in the World devoted to the manufacture and importation of musical instruments and the publication of music." In 1922, the building became the home of the Moore School of Engineering.

This magnificent Georgian Revival building, housing the law school (now called Silverman Hall), is located at 34th and Chestnut Streets. It was designed by the architectural firm of Cope and Stewardson, which designed many of the University of Pennsylvania's buildings. Built in 1900, it still stands as one of finest buildings on the campus. The ivy-covered houses in the foreground became a women's dormitory. This postcard view was made in 1908.

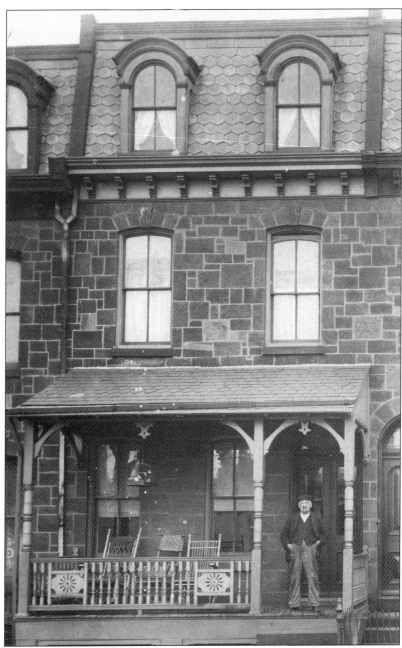

This proud homeowner is standing on the front porch of his house at 3422 Sansom Street. This row of Second Empire–style houses was built c. 1870. A hanging birdcage and several rocking chairs adorn the front porch, which was probably added in the 1880s. Over the years, the row was home to important artists, sculptors, architects, engineers, and the dean of the School of Fine Arts, G. Holmes Perkins. In the 19th century, Madam Elena Blavatsky, founder of the Theosophists, also lived on this block. Remarkably, the row is still standing, only after a successful legal battle led by property owners and supported by university faculty members who wanted a place to have a drink at lunchtime. Today it is called Sansom Row and is on the National Register of Historic Places. Sansom Row is a quaint reminder of earlier days on campus.

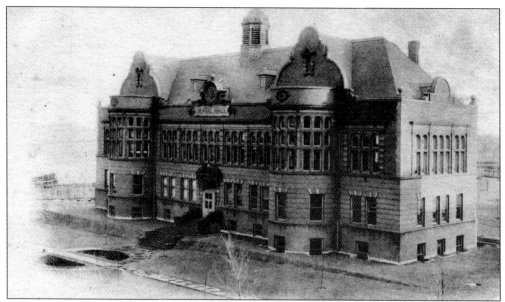

Standing today on the 3300 block of Smith Walk is the old dental school (now called Hayden Hall), shown here in 1905. The building was built in 1895 and was designed by architect Edgar V. Seeler in a Dutch style. It was renamed the Fine Arts Building, when in 1915 the dental school moved to the new Evans School of Dentistry at 40th and Walnut Streets.

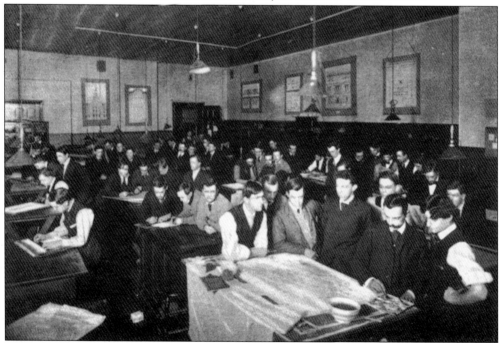

This c. 1905 postcard is part of a set of postcards featuring the University of Pennsylvania School of Architecture, which was established in 1890. The drafting room was in College Hall and was lighted with what seems to be a primitive bare-bulb lighting system and pull-down lamps that could be lowered over the students' drafting tables. In 2001, women made up almost half the students graduating from the School of Architecture.

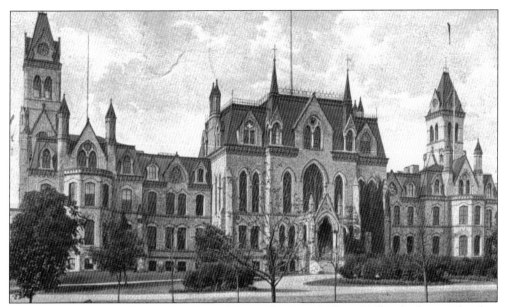

This 1906 view shows the University of Pennsylvania's College Hall, which was the first building constructed on the new campus, in 1872. It was designed in the Gothic Revival style by architect Thomas Richards. When it was built, College Hall housed all the functions of the young university, including a gymnasium and chapel. It still stands today. Its two Gothic towers were demolished by 1929.

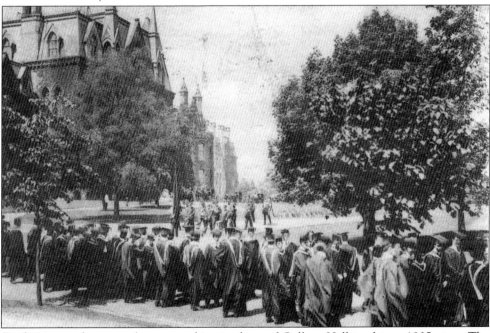

Graduating students are shown marching in front of College Hall in this c. 1905 view. The students marched across the Walnut Street Bridge to the Academy of Music on South Broad Street, where commencement ceremonies were held. In the middle of the picture is a German marching band. In the background are the carriages to carry the faculty to the ceremonies; they did not have to march.

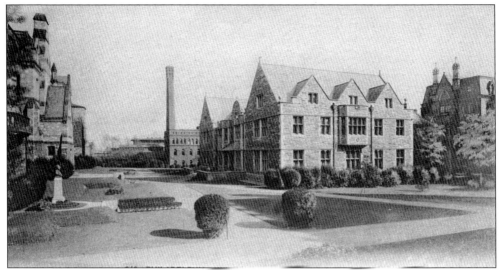

Opened in 1896 as the first college student union in the United States, Houston Hall was a gift of university trustees Henry and Sallie Houston. This *c.* 1905 postcard view is looking east on the south lawn of Houston Hall, with College Hall on the left. Houston Hall was designed to look like an elegant English men's club by architectural students William Hays and Milton Medary, who won a student competition.

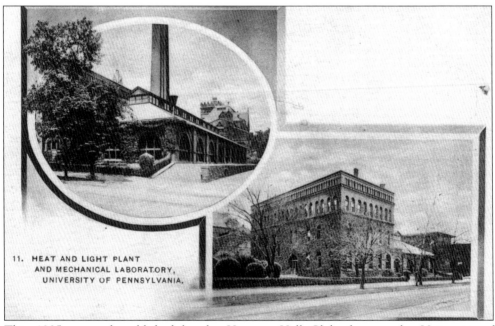

11. HEAT AND LIGHT PLANT
AND MECHANICAL LABORATORY,
UNIVERSITY OF PENNSYLVANIA.

This 1905 postcard, published by the Houston Hall Club, features the University of Pennsylvania's huge heat and light plant and the new Mechanical Laboratory Building at 34th and Spruce Streets. The heating plant was torn down in 1926 to make way for Irvine Auditorium.

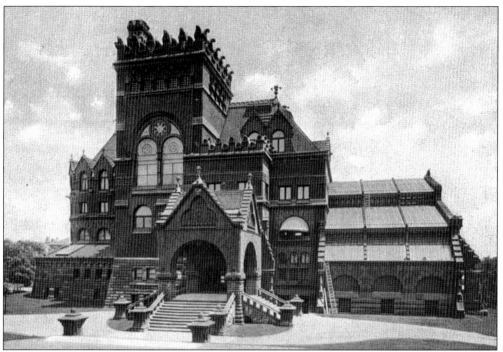

Opened in 1881, the Furness Library (at 34th and Walnut Streets) is now called the Fisher Fine Arts Library. It is one of the finest architectural works of 19th-century architect Frank Furness. His unique design is sometimes called the "marriage of a cathedral with a railroad station." It is surely one of the must-visit architectural sites on the University of Pennsylvania campus.

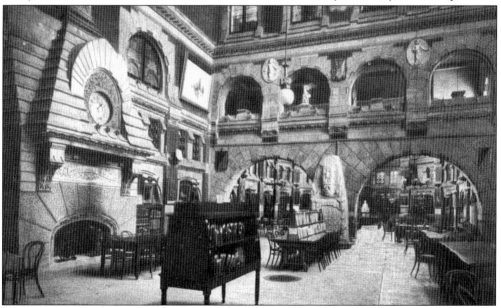

The Furness Library, with its original skylighted stack area, is shown here in 1906. This image shows the interior of the Furness Library's main reading room. A massive working fireplace is seen on the left, designed in typical Frank Furness high Victorian style. The reading room is flooded with natural light from many high windows and a ceiling skylight.

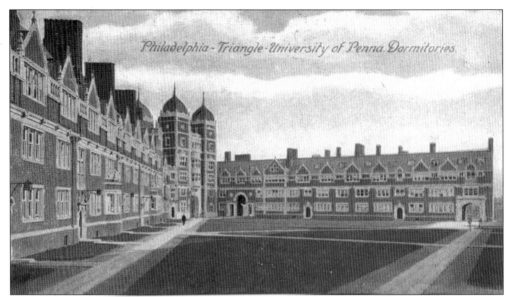

The Triangle dormitory of the University of Pennsylvania was built in the English Collegiate style in 1898. This early postcard (c. 1905) shows it open-ended. In 1908, it became the Quadrangle. The architectural firm of Cope and Stewardson's eclectic design included Jacobean, Renaissance, Tudor, and Gothic design elements to give it a "ye olde" English ambiance. Unlike modern student dormitories, each Quadrangle dormitory house was unique in some way.

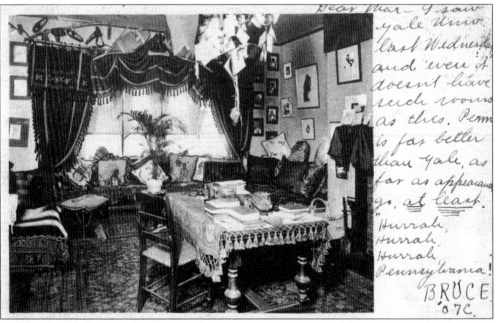

On this postcard, a member of the Class of 1907 writes, "Dear Mar— I saw Yale Univ. last Wednesday and even it doesn't have such rooms as this. Penn is far better than Yale, as far as appearances go, *at least*. 'Hurrah, Hurrah, Hurrah, Pennsylvania!' Bruce '07C." The overstuffed dormitory room featured in this 1905 postcard was decorated in the height of late-Victorian design with enough bric-a-brac to fill every corner.

This elegant Renaissance Revival Phi Kappa Sigma fraternity house (at the northeast corner of 36th and Locust Streets) still stands today on what was then called Fraternity Row. When this postcard view was made in 1910, the fraternity house had been just completed. It was designed by architectural firm of Bissel and Sinkler.

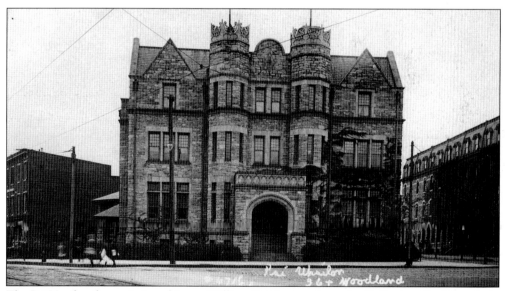

The Psi Upsilon fraternity's architect, William D. Hewitt, chose the Collegiate Gothic style in 1897 for this fraternity house at the corner of 36th Street and Woodland Avenue. Woodland Avenue is on the left, and a row of four-story houses on the 3600 block of Locust Street is on the right. In the 1950s, the building was the Christian Association Building.

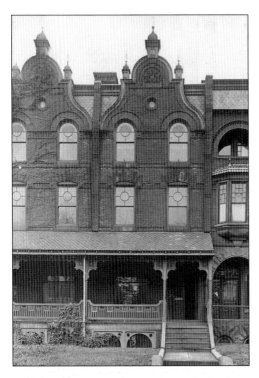

This eclectic, late-Victorian row house at 3450 Walnut Street was the home of the Psi Omega fraternity in 1908. It is typical of middle-class row houses built in University City *c.* 1890. These houses had elaborate woodwork, fireplaces, servants' stairs, central heating, and all the modern conveniences of the day. The architect tried to give variety to their exterior elevations by changing the design for every pair of houses.

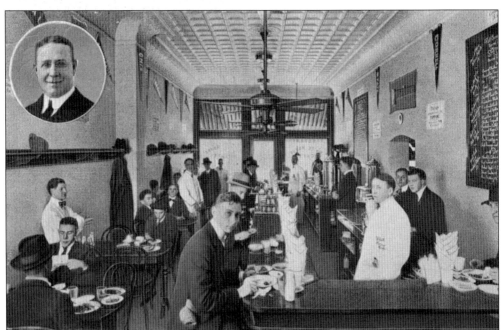

At 3657 Woodland Avenue was the White House Café, strategically situated across from the new Quadrangle dormitory. Its motto, written on the back of this postcard, was "The Place to meet your College Chums." J.S. Greasley was the proprietor when this card was published *c.* 1917. His picture is in the upper left-hand corner. When labor was cheap, five white-coated waiters stood by, ready to serve the student patrons.

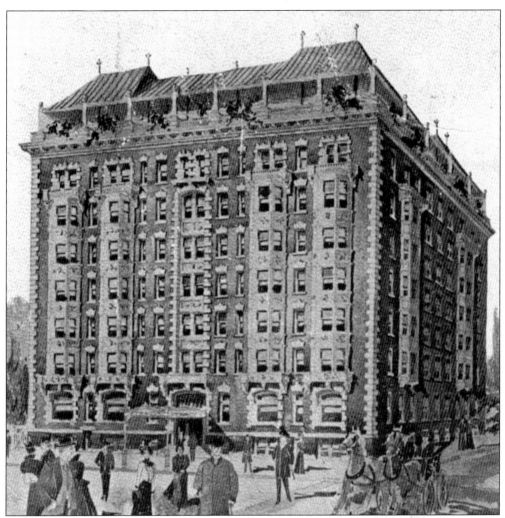

The Tracy Apartment House, built in 1901 and designed by architects Milligan and Webber, is located at 36th and Ludlow Streets. The Tracy is shown here in an architect's rendering on a postcard view from 1907. It had an elaborate roof garden, typical of apartment houses of the day. The Tracy was bought in 1949 by Father Divine's Peace Mission Church and renamed the Divine Tracy Hotel. In keeping with the teachings of Father Divine, the hotel was integrated at a time when most Philadelphia hotels did not cater to clients of color. At great expense, the Peace Mission completely renovated the building. Its Keyflower Dining Room is one of the most popular eating places on the University of Pennsylvania campus and is known particularly for its holistic and macrobiotic menu. Father Divine's code requiring no undue mixing of the sexes is strictly observed in the Divine Tracy Hotel.

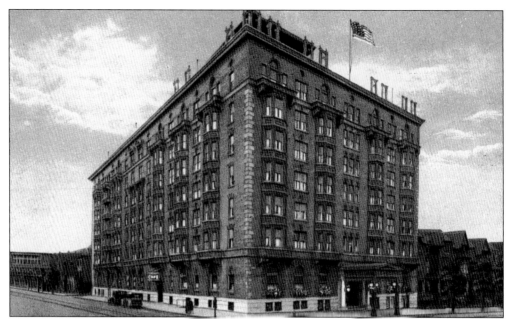

Rapid trolley service to University City made it a convenient place to live. Consequently, large luxury apartment hotels were built in the University City c. 1901. Shown in this 1915 postcard, the Hotel Normandie (at the 37th and Chestnut Streets) was one of them. The Normandie's architects were Milligan and Webber, who specialized in hotel design. Unfortunately, the Normandie had a disastrous fire in 1968 and had to be demolished.

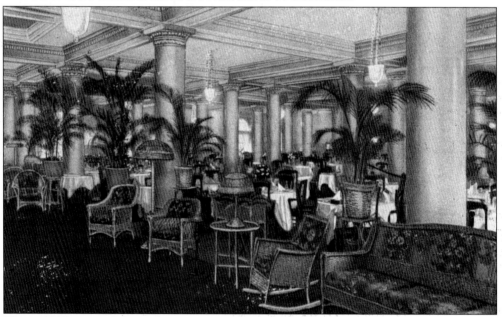

This c. 1915 postcard shows the entrance to the main dining room of the Hotel Normandie in its heyday. The dining room, which was on the lobby floor of the hotel, had a forest of columns supporting the floors above. Because of this structural problem, hotels of this period, such as the Bellevue Stratford and Lorraine, were built with their large public rooms on the hotel's top floors.

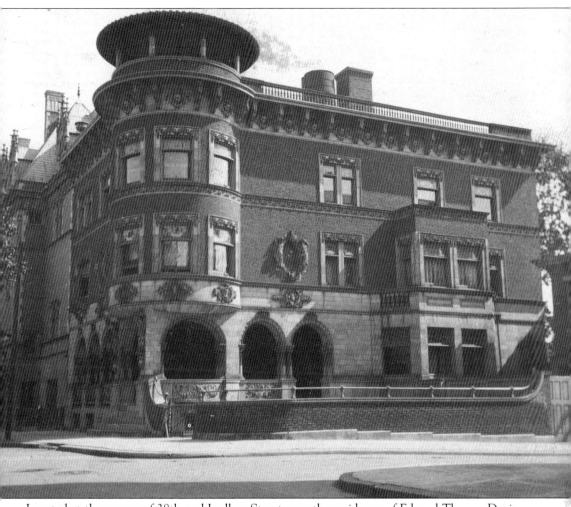

Located at the corner of 38th and Ludlow Streets was the residence of Edward Thomas Davis. The Colonial Revival house was built in 1897 and was designed by architect Willis Hale. This real photo postcard view is from 1910. Davis, a well-to-do real-estate operator, was connected with William Weightman Properties, Philadelphia's largest landowner. Hale had just finished designing 10 houses at 38th and Locust Streets for Weightman when he designed the Davis house. Unfortunately, this house is no longer standing. Still standing is a similar Hale-designed house, built for John Stafford in 1895 at the northwest corner of Broad and Norris Streets in North Philadelphia.

The Church of the Saviour is located at 38th and Ludlow Streets. In the foreground of this 1910 postcard is the elaborate entrance to the Davis mansion. Across Ludlow Street is the rebuilt Church of the Saviour, now called the Cathedral Church. The church seen here was the third building constructed on the site. The first was built in 1855. In 1889, a new church was built on the site, only to be destroyed by a disastrous fire on April 6, 1902. Architect Charles Burns was put in charge of the reconstruction, which resulted in the fine church still standing today. In the background can be seen the tower of the St. James Roman Catholic Church (designed by architect Edwin Durang), at 38th and Chestnut Streets.

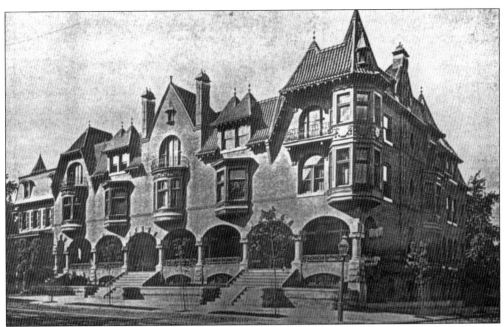

In 1891, architect Willis Hale designed seven row houses at the northwest corner of 37th and Chestnut Streets (above) and the row of nine houses located at the northwest corner 39th and Spruce Streets (below) for William Weightman. Hale was known for his original designs that were very picturesque, often mixing several architectural styles in one design. Chimneys, broken rooflines, porches, balconies, and bay windows were all design devices used to give each row house individual character. He was the favorite architect of developers William Weightman and P.A.B. Widener in the 1890s. At one time, his residential designs could be found all over West and North Philadelphia. Unfortunately, as with many of Hale's designs, these rows of houses did not survive into the 21st century.

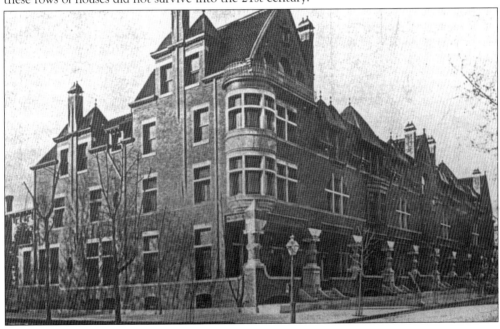

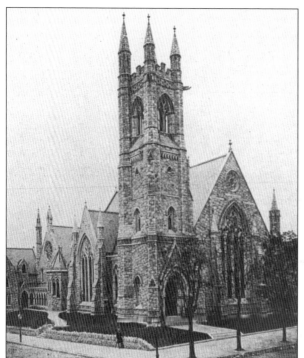

This view of the Tabernacle Presbyterian Church is from the book *West Philadelphia Illustrated* (1903). Located prominently at 37th and Chestnut Streets, the church (built in 1885) is a testament to the civic pride and piety of 19th-century West Philadelphians. Well-known Philadelphia society architect Theophilus Chandler was the architect of this Gothic-style church. It was one of many churches on Chestnut Street.

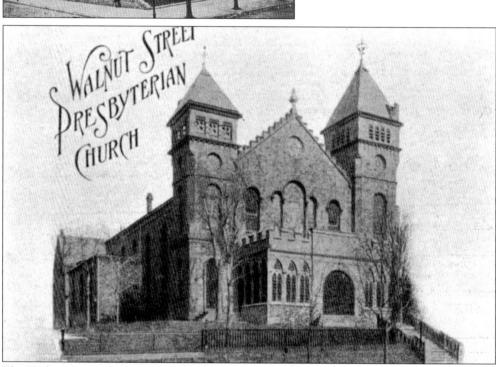

The Walnut Street Presbyterian Church, founded in 1828, was located on Walnut Street above 39th Street and was an old West Philadelphia church. The building, shown here in a 1905 postcard, was built in 1859–1860 and designed by prominent Philadelphia architect Stephen Decatur Button. It had a prominent frontage on Walnut Street of 100 feet. The church is no longer standing.

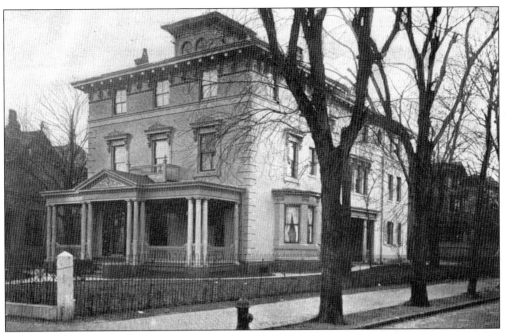

At the southwest corner of 40th and Pine Streets was the home of David Porter Leas, a leather manufacturer. His house was originally an 1860s Italianate villa, but he had it enlarged and modernized into a Colonial style c. 1900.

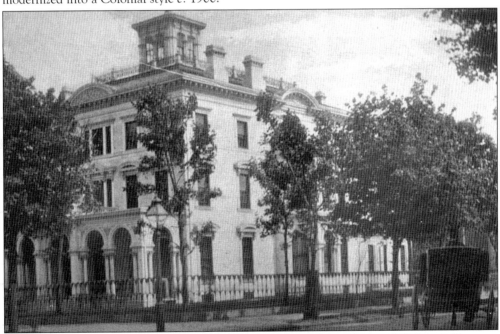

In the late 19th century, this house was located at the southeast corner of 39th and Chestnut Streets. Originally a small house built in 1839, it was completely remodeled in the 1860s into an Italianate villa by the very wealthy William G. Morehead, a partner of financier Jay Cooke. When the last owner Charles Wright died, the property was sold. In 1901, the Hamilton Court Apartments were built on the site.

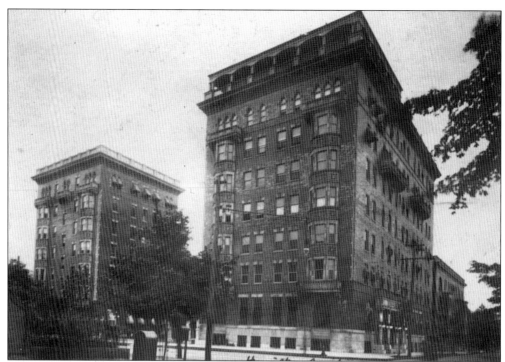

This view from 1909 shows perhaps the most luxurious West Philadelphia apartment house of its time, the Hamilton Court Apartments, located at 39th and Chestnut Streets. Hamilton Court was designed in 1901 by Milligan and Webber, who also designed the Tracy and Normandie hotels. It had an elaborate roof garden and a beautifully landscaped courtyard that has since been paved over for parking.

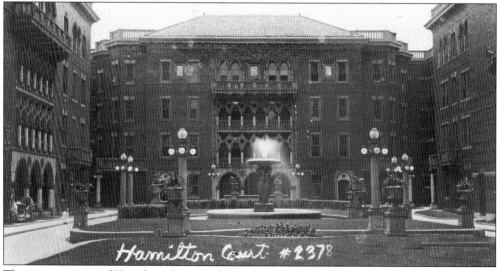

The interior court of Hamilton Court is shown in 1909. The elaborate courtyard was designed with architectural motifs borrowed from the Doges' Palace in Venice, Italy. It had a fountain and specially designed electric lights on columns and must have been a very impressive sight when it opened in 1901.

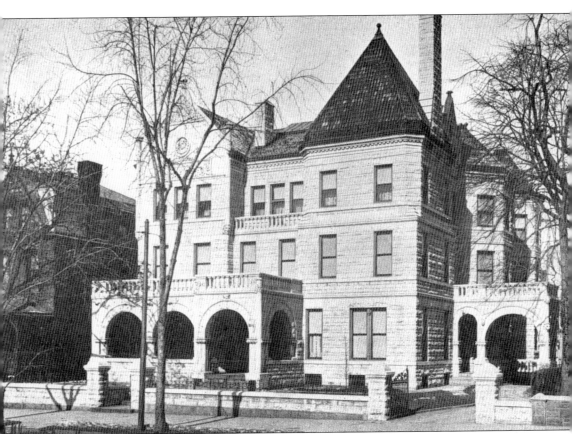

Pictured in 1902, the William J. Swain residence, located at 3925 Chestnut Street, was on one of the most fashionable blocks of University City. Swain was a lawyer, editor, publisher, and founder of the *Public Record* newspaper. Designed in the 1890s by architect Will Decker in a Romanesque style, the house had an elaborate interior full of elegant stained-glass screens and doors and carved woodwork. It is said that the carved faces of children on the house's grand staircase were portraits of the Swain children. In 1926, the house was purchased from the Swain family by the Andrew Bair Funeral Home. In 1982, it was acquired by Children's Hospital for use as the Ronald McDonald House for Children. Another example of Decker's Romanesque house design can be seen at 1430 North Broad Street in North Philadelphia. Unfortunately, very few examples of Decker's work still exist.

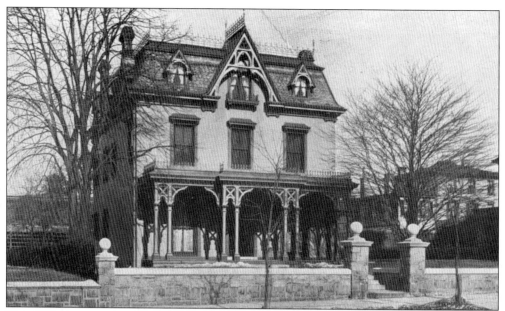

This 1902 photograph, published in *King's Views of Philadelphia*, shows John Hanson Michener's home, located at 3913 Chestnut Street. Michener was the president of the Bank of North America and was the head of J. Michener & Company, provisions packers. Moses King described the style of the residence as being "modernized Colonial." The design was actually an eclectic style, combining the elements of Second Empire and Italianate architecture. It is no longer standing.

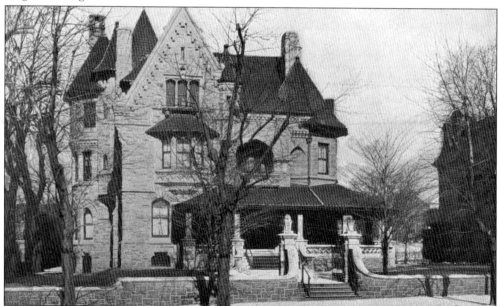

Another photograph from *King's Views of Philadelphia* shows Monroe Smith's home, located at 3919 Chestnut Street. Smith's occupation was noted by King as being a "capitalist." King stated at that time that the house was the "most costly of West Philadelphia homes." The house, which is no longer standing, was designed by renowned Philadelphia architect William L. Price in 1892 in a French Gothic style.

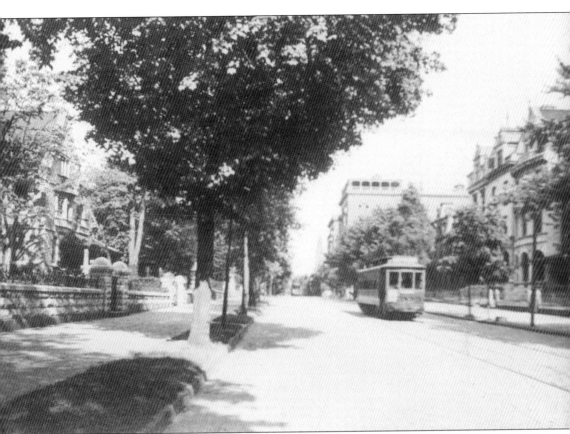

This rare photograph of the 3900 block of Chestnut Street is from a 1912 book about the port and city of Philadelphia. Published by the City of Philadelphia to promote foreign trade, it was printed in German and entitled *Hafen Und Stadt Philadelphia*. The photograph is captioned "*Im Villenviertel*, West Philadelphia" (Mansion District, West Philadelphia). The tall building in the center of the picture is the Hamilton Court Apartments. The stone wall and iron gates on the left are in front of the Swain mansion, at 3925 Chestnut Street. Next to the Swain mansion, the Smith mansion (3919 Chestnut Street) is visible. The Smith mansion was later torn down to make a parking lot for the Andrew Bair Funeral Home. Across the street were three of the most elegant townhouses built in West Philadelphia. They were constructed in 1896. Their French design is attributed to architect Horace Trumbauer. In this 1912 view, Chestnut Street was serenely devoid of traffic except for the two trolleys.

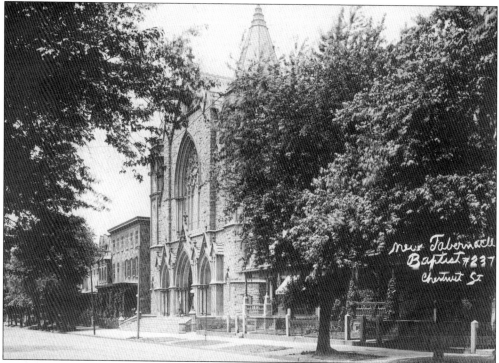

The New Tabernacle Baptist Church, designed by architect Frank Watson, was dedicated on March 7, 1897. It is shown here in a 1907 postcard view. An 1872 Philadelphia atlas shows that originally the Berean Baptist Church was located on this site on the 4000 block of Chestnut Street. The new Gothic-style church resulted from the union of two Baptist churches—Berean Baptist and Tabernacle Church (located at 18th and Chestnut Streets).

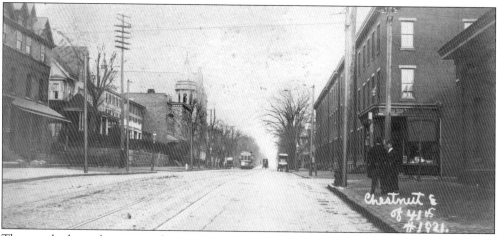

The couple shown here is standing in front of the trolley depot on the northwest corner of 41st and Chestnut Streets, where the trolley line ended. In this 1906 postcard, a lone trolley car is travelling west on Chestnut Street to the trolley barn. The twin towers of the New Tabernacle Baptist Church can be seen in the middle of the 4000 block of Chestnut Street.

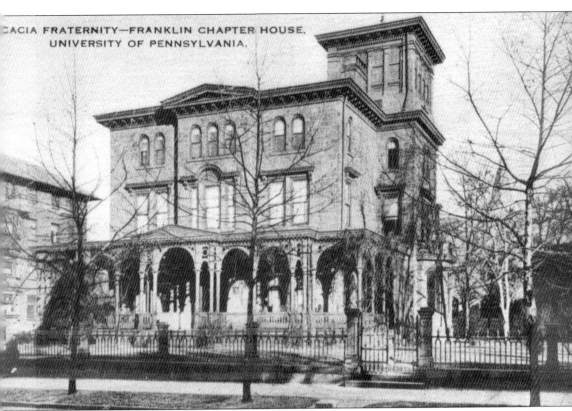

Built at 3907 Spruce Street after the Civil War by the Harris family, this Italianate-style villa, compete with cupola, was one of six large single houses that once occupied the north side of the 3900 block of Spruce Street. In 1897, the Harris family sold the house to Anthony J. Drexel. After his death, his heirs sold it to Clarence S. Bement in 1900. In 1922, it was purchased by the Franklin chapter of the Acacia fraternity for its chapter house. It remained a chapter house until 1965, when the university purchased it and demolished the house, leaving only the rear carriage house standing. To the right at 3905 Spruce once stood the Potts mansion, which later became the home of WXPN radio. The carriage house at the rear of 3905 Spruce, added in 1887, is now the home of the University of Pennsylvania's Lesbian Gay Transgender Center. Renamed the Carriage House, the building was restored by a $2 million gift from two graduates who became multimillionaires working for Microsoft.

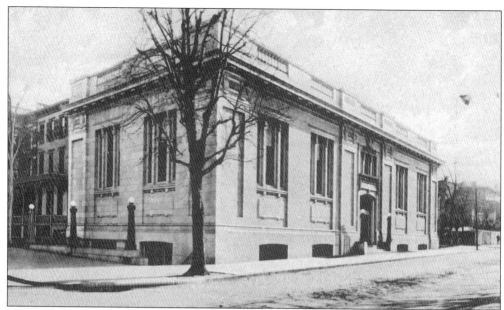

This 1906 view shows the West Philadelphia Branch of the Free Library, at the southeast corner 40th and Walnut Streets. The money to build the library was a gift from Andrew Carnegie. The land was a gift of philanthropist Clarence H. Clark. His nephew and University of Pennsylvania architectural graduate, Clarence Clark Zantzinger, was the architect of this elegant Beaux-Arts design. This was Zantzinger's first major commission, starting him on his illustrious architectural career.

These Second Empire–style houses on 42nd Street north of Locust Street were built around the time of the centennial. At that time, they were almost at the western edge of University City's development. Across 42nd Street was the block-long garden of the Sinnott mansion, open land, and virgin forests. In 1879, the residents' bucolic view was blocked when St. Mark's Square was built on half of the Sinnott garden.

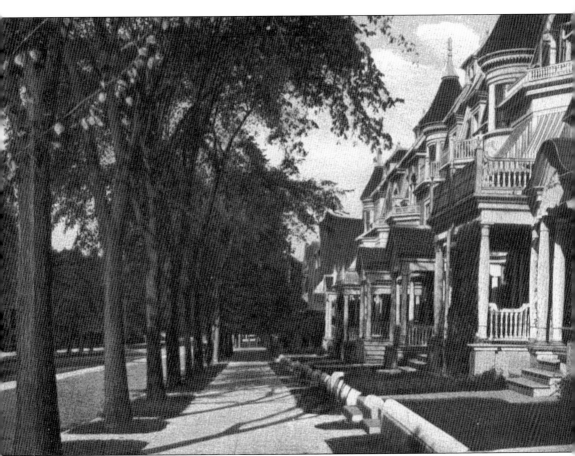

This very popular postcard's idealized view of West Philadelphia was printed c. 1906. Looking west toward 41st Street, it shows the north side of the 4000 block of Spruce Street. Because the houses face south, they had awnings and shade trees to help keep them cool. This row was built in 1896 by developer J. Clark Moore in the latest Colonial Revival style, some with three floors of elegantly detailed front porches. The postcard publisher, the H.C. Leighton Postcard Company, painted in a grass strip down the middle of Spruce Street. At the west end of the block were earlier houses, dating from 1877 and designed by architect Frank Furness for developer Clarence H. Clark. This block is still standing.

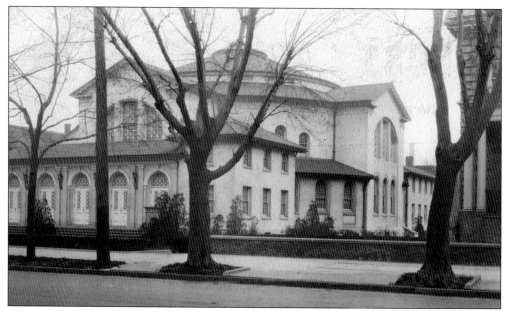

Designed by New York City's fashionable society architects Carrere and Hastings in 1911 was the First Church of Christ, Scientist, located at 4012 Walnut Street. Now called the Rotunda, this magnificent church, elegant in its simplicity, was designed to look like an early Christian church. It had a tile roof and great Roman arched windows to light the rotunda space. The building still stands.

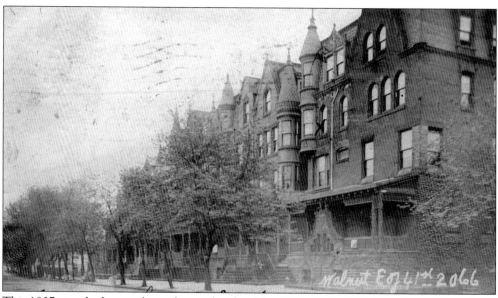

This 1907 view looks east down the south side of the 4000 block of Walnut Street. These huge four-story twin houses were probably the work of architect Willis Hale. They were designed in a picturesque 1890s Queen Anne style and were built high above the street to make a statement of the owner's wealth. At the far end of this block is the First Church of Christ, Scientist.

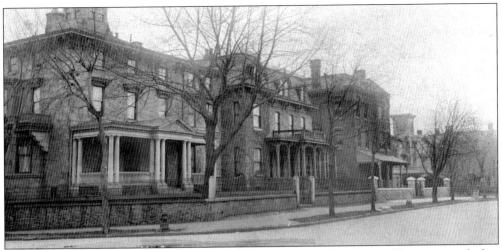

This is a 1907 view of the south side of the 4100 block of Walnut Street. There were only five very large houses on the block at the time. The corner house is in the Italianate style with a center cupola and dates from *c.* 1870. It also had a "modern" new Colonial Revival front porch.

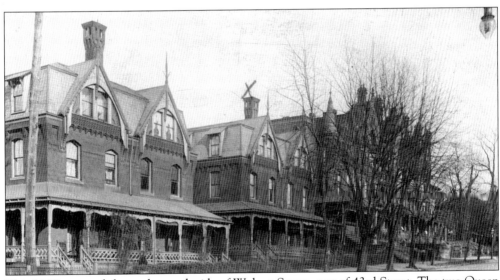

This 1907 postcard shows the south side of Walnut Street, east of 43rd Street. The two Queen Anne–style twin houses in the foreground were designed in 1880 by Hewitt Brothers, architects. Behind the trees is an extravagant row of four-story double houses, designed *c.* 1890 by architect Willis Hale. Hale built these houses high off the street, with tall chimneys to make them look even more impressive.

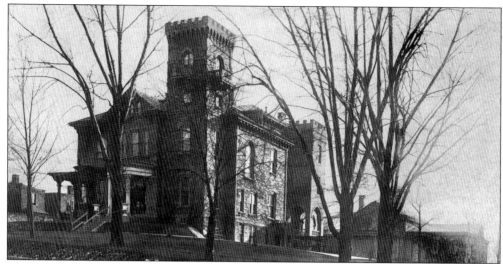

This 1907 view shows the rusticated Italianate villa of Joseph F. Sinnott at the southeast corner of 43rd and Walnut Streets. At one time, it occupied the entire block to 42nd Street. In 1879, more than half the block was developed into the row houses of St. Mark's Square. Joseph F. Sinnott was owner of Moore & Sinnott Distillers and director of the First National Bank.

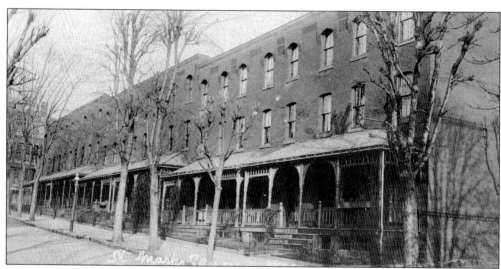

St. Mark's Square (running between Locust and Walnut Streets, west of 42nd Street) was designed by the Hewitt Brothers and looks the same today as it does in this 1907 view. The street was home to professors and students of the University of Pennsylvania for over 100 years. Margaret Mead, famous anthropologist, lived on the block as a child, and it is now home to historian and poet Ruth Molloy.

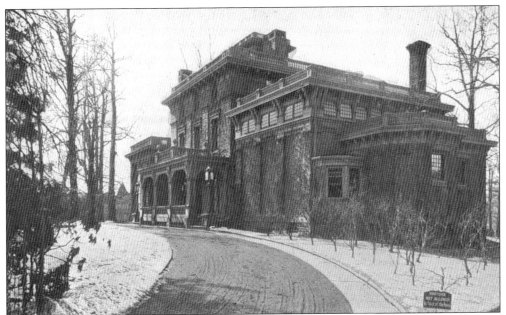

In 1902, the estate of Clarence H. Clark, financier, developer, and philanthropist, occupied the entire block at the southwest corner of 42nd and Locust Streets. Clark is best known for his gift of land to the City of Philadelphia for Clark Park and the West Philadelphia Branch of the Free Library, at 40th and Walnut Streets. A divinity school was built on the site in the 1920s; only the iron gates to the estate remain today.

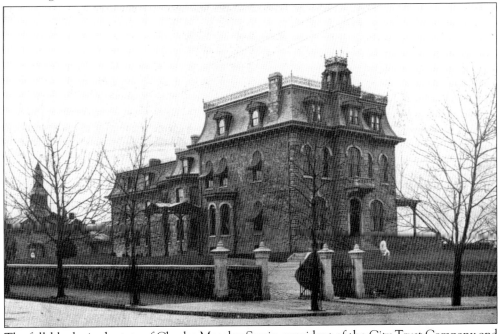

The full-block-sized estate of Charles Moseley Swain, president of the City Trust Company and son of the founder of the *Public Ledger* newspaper, was located on the southwest corner of 45th and Spruce Streets. It was a grand Second Empire–style villa with a huge carriage house in the rear. In the 1960s, it was demolished to make way for the University Mews housing.

47

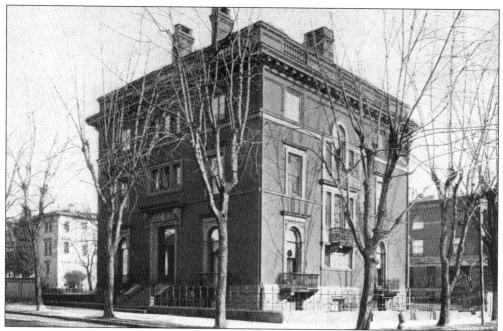

Designed by Wilson Brothers & Company in 1892, the Renaissance Revival–style house at the northwest corner of 39th and Locust Streets was built by Anthony J. Drexel for his youngest son, George Childs Drexel. Anthony Drexel and his other son also lived on the block that came be known as the Drexel Block. In 1902, the house belonged to Dr. Shriver Wentz, the owner of the Westmoreland Coal Company. It later became a fraternity house.

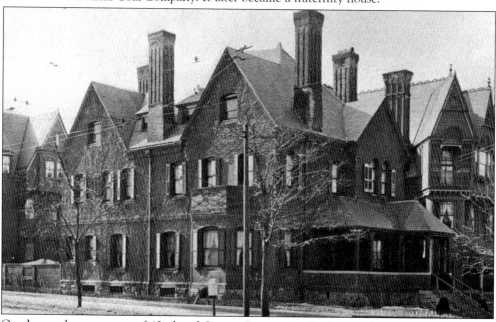

On the southwest corner of 42nd and Spruce Streets was the home of Clarence H. Clark Jr., financier and "clubman." The architects for this English Gothic and Queen Anne house were Andrews, Jacques & Rantoul. To the right of the Clark house is the beginning of the Queen Anne–style houses designed by Hewitt. The Clark house is a fraternity house today.

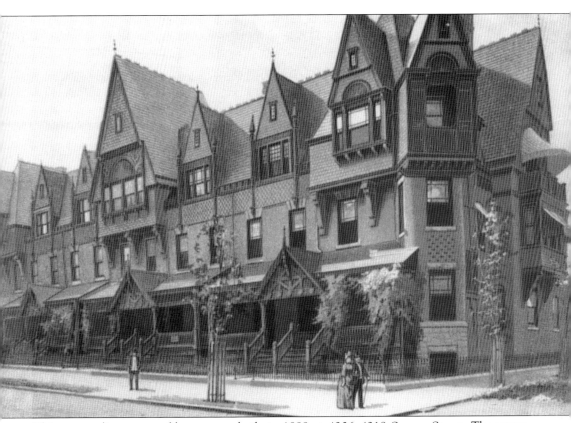

This extraordinary row of houses was built in 1888 at 4206–4218 Spruce Street. They were designed by architects G.W. and W.D. Hewitt in the latest Queen Anne style. The facades have decorative wood trim, fish-scale shingles, brick corbels, and ornamental wrought-iron details. Probably the best residential work of the Hewitt Brothers, this picturesque row is still standing today. The Hewitt Brothers were obviously influenced by the Queen Anne design of architects McKim, Mead and White for the casino in Newport, Rhode Island, completed seven years earlier. Although the picture's caption calls these houses "Philadelphia Houses of Moderate Cost," they were much more extravagant in size and detail than the typical moderate West Philadelphia row houses of the period.

This rare *c.* 1900 photograph shows potato fields at 45th and Walnut Streets. The H.G. Hopkins *1872 Atlas of West Philadelphia* map shows this area west of 42nd Street as largely undeveloped at that time, a crazy quilt of farms and estates, crisscrossed by free-running creeks. There were Colonial farmhouses, a cotton mill, and old inns, such as the Cherry Tree Inn (at 47th Street and Baltimore Avenue) and the Blue Bell Inn (on the Old Darby Road). After 1872, as the horsecar lines extended westward, the old sections, such as Kingsessing and Satterlee Heights (once the site of a large Civil War hospital) rapidly developed. By 1908, after the Market Street Elevated opened, the area west of 42nd Street, including this potato field, was almost completely built-up with rows of houses. (Courtesy family of Catherine Crown O'Kane.)

Two

SPRUCE HILL, WALNUT HILL, AND CEDAR PARK

In the 1890s, trolley lines were constructed along Woodland, Chester, Baltimore, and Springfield Avenues. The lines opened new lands for development south and west of University City. The electric streetcars traveled to Center City at a remarkable 15 miles per hour. Within a few years, these main avenues and adjacent cross streets had newly constructed row and twin houses built for a commuting white-collar middle class. The houses were first designed in the Queen Anne style. By the late 1890s and 1900s, the Colonial Revival style was most favored by prospective homeowners and developers. Some rows have a combination of both styles indicative of the transitional style of houses. In addition, c. 1900, apartment houses were built on corner lots, many built in the Romanesque style, such as the Stonehurst and Sedgley. Spruce Hill, Walnut Hill, and Cedar Park were new neighborhood concepts—bedroom communities, purely residential, with no corner stores and no stables. The houses were big, and the streets were lined with trees. Automobile garages were to yet come into use. Baltimore Avenue and 47th Street north of Kingsessing were the neighborhood shopping districts. In 1909, the city enhanced the neighborhoods by building Clark Park and Cedar Park. At the turn of the century, many new churches were built. For example, in 1906, architect Henry Dagit designed the Byzantine domed St. Francis De Sales Roman Catholic Church, at 47th Street and Springfield Avenue. The Calvary United Methodist Church, at 48th Street and Baltimore Avenue, was built in 1907 and was designed by architects Brown, Gillespie and Carrell. The church was noted for its magnificent Tiffany stained-glass windows. These great churches and many others built in Spruce Hill, Walnut Hill, and Cedar Park in the early 20th century are all testaments to the affluence and piety of the residents.

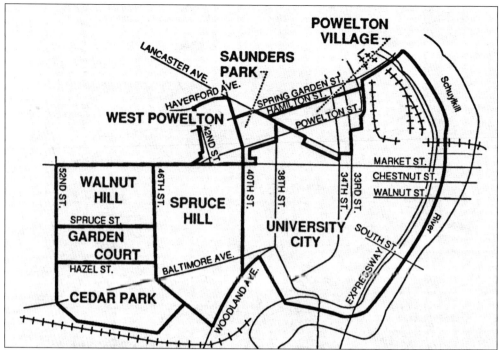

Originally, all the areas shown on this map were identified only as West Philadelphia. The map shows the boundaries of West Philadelphia neighborhoods bordering University City as once designated by the Philadelphia City Planning Commission. The commission has since combined all these neighborhoods east of 52nd Street, shown on the map under one heading, now calling them "University City Neighbors."

This real photo postcard was made c. 1907 by Klein Brothers Photo of 4209 Chester Avenue. It shows some of extravagant Second Empire–style twin houses that once lined the 4200 block of Chester Avenue. They are no longer standing.

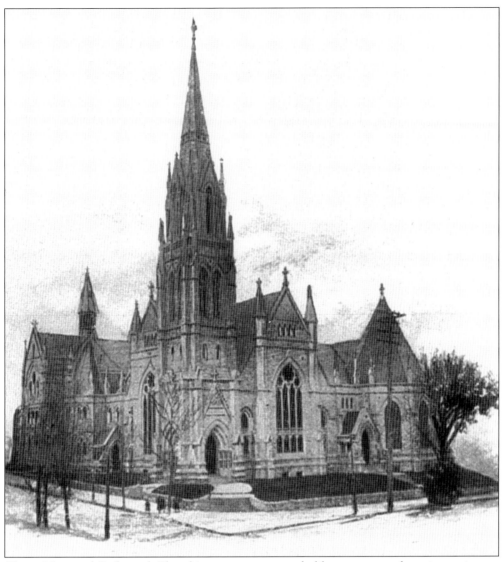

Christ Memorial Reformed Church's great tower stands like a great exclamation point on Chestnut Street. This magnificent church, which is a complex of three contiguous buildings (the seminary, sanctuary, and parish hall), was built in 1887 at 43rd and Chestnut Streets. The architects were Pursell and Fry, who were responsible for the designs of many beautiful churches in West and North Philadelphia in the 1880s and 1890s. Because of the streetcar line and the street's prestige, Chestnut Street was a favored street for church building. From 38th to 43rd Streets, four 19th-century churches were built on Chestnut Street, each one with an impressive tower, giving the street its great architectural character. This photograph is from *West Philadelphia Illustrated* (1903).

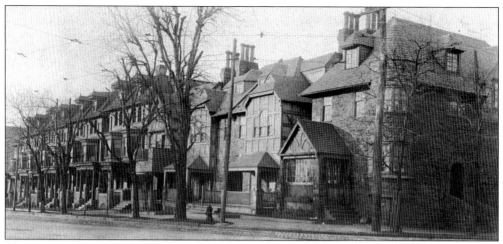

This group of semidetached houses was located on northwest corner of 45th and Spruce Streets. They were just built when this postcard was mailed in 1907. Developer Charles J. Swain constructed the houses in a picturesque English Tudor style with tall chimney pots and exposed wood trim. Stylistically, they were 20 years ahead in architectural design than their large four-story neighbors built at the same time.

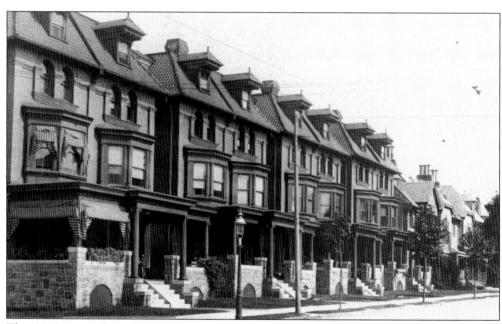

This 1907 view is from the opposite end of the block, the northeast corner of 46th and Spruce Streets. This Colonial Revival design was used repeatedly in the Cedar Park area after 1900. Developer Charles Budd built the houses for the upper middle class and provided them with many bedrooms for their large families and their many servants. (Courtesy Howard Watson.)

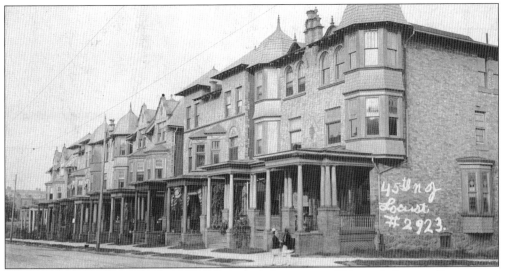

This transitional-style block of semidetached houses at 45th and Locust Streets was photographed in 1907 by Mercantile Studio. The houses were built before 1900 and have Queen Anne influences in the turreted corners and rooflines, with a Colonial-style front porch. Although they are semidetached, there really was not much space between the houses, so the side bay windows did not receive much light or air.

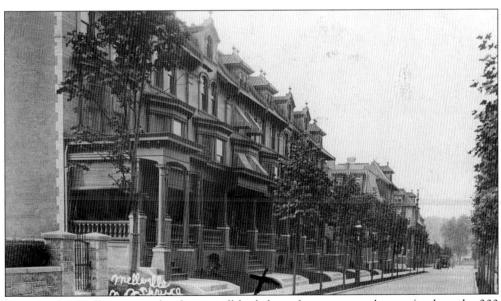

Even on the smaller streets, developers still built large four-story row houses (such as the 200 block of South Melville Street, which runs from Spruce Street to Walnut Street). This 1907 postcard view, looking north, shows newly constructed Colonial Revival houses. The immaculately kept street was just planted with young trees.

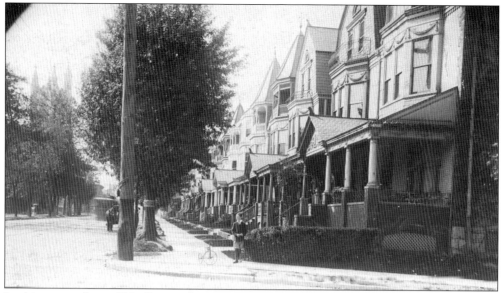

Looking west from 47th Street, this *c.* 1907 view shows a block on Baltimore Avenue. Developer George G. Henderson built the twin homes in 1893. The Colonial Revival style had just come into fashion. By changing the projecting bays, adding porches, and differing rooflines, the architect made the whole block into an interesting composition.

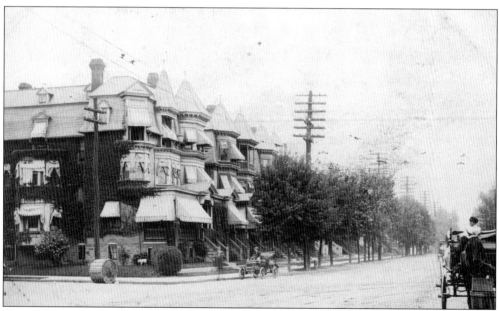

This 1907 postcard view shows 49th Street and Baltimore Avenue. Porches, awnings, thick walls, and shade trees all helped to keep these large Cedar Park homes cool during the summer months. In the foreground is a horse cart, the future of which as a means of transportation is foretold by the automobile parked diagonally across the intersection. Automobiles would become a common sight on West Philadelphia streets within a few years.

56

This 1907 view of the Calvary United Methodist Church, at 48th Street and Baltimore Avenue, was made the year the church was completed. It was designed by Brown, Gillespie, and Carrell and was noted for its domes and magnificent Tiffany stained-glass windows. Like Chestnut Street, Baltimore, Chester, and Cedar Avenues were favorite streets on which to build churches because of the streetcar lines.

This handsome 1907 postcard shows St. Paul's Presbyterian Church, well situated at the intersection of Baltimore Avenue, Catharine Street, and 50th Street. The church was built in 1904 and designed by Pursell & Fry. In the foreground is the new Cedar Park, built on a triangle of land by the city in 1906 after the Cedar Avenue Improvement Association successfully pressured the city to build a park there.

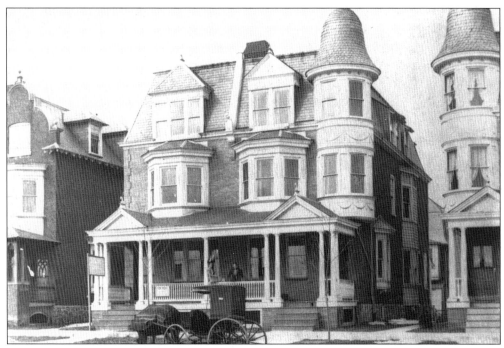

This *c.* 1898 photograph shows 5017 Cedar Avenue. The house next door has a For Rent sign on the porch, and the horse seems to be taking advantage of the grass from the sidewalk strip. To add variety into his building designs, the builder-developer mixed styles and reversed the location of the cupolas on the houses, making each house in a pair different. (Courtesy the Gables Inn.)

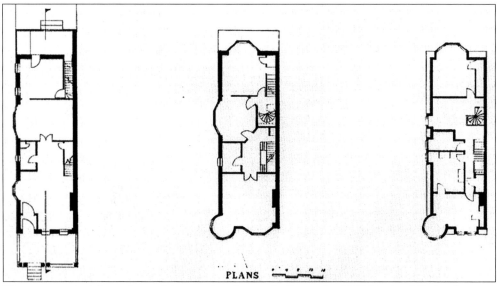

PLANS

These are typical floor plans of the spacious houses built on the 5000 block of Cedar Avenue. The first-floor plan is shown on the left, the second in the middle, and the third on the right. Note the spiral servants' stairs from the second to third floors. These plans are for 5019 Cedar Avenue. They were drawn by University of Pennsylvania architectural student Osia Orailogla in 1979.

58

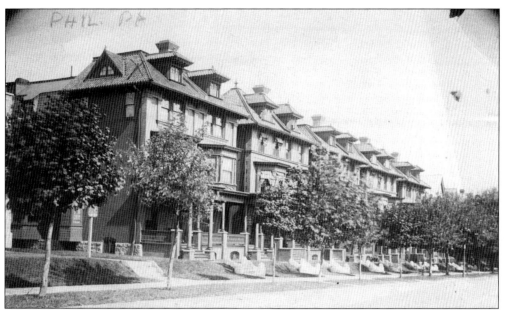

Above is Cedar Avenue in a 1907 view looking northeast from 47th Street. Below, on the same date, is the southeast corner of 48th and Cedar. Both housing groups were built *c.* 1903 by developer Charles W. Budd in a Colonial Revival style, very popular among developers of speculative housing in Cedar Park. The corner house of 48th and Cedar has stained-glass windows in the living room, dining room, and bedrooms. These large houses were built for the white-collar middle class who commuted to work by trolley to University City and Center City.

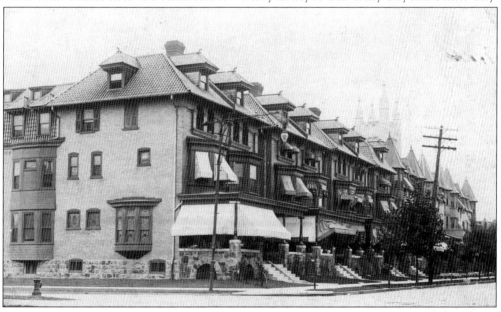

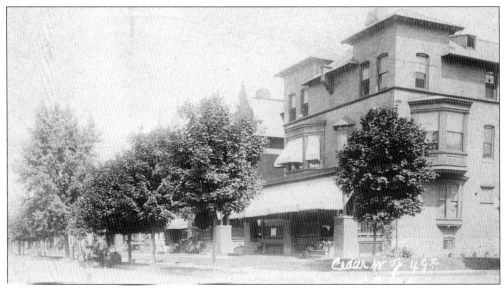

Shown c. 1907 is Cedar Avenue west of 49th Street. Cedar Avenue was developed with large houses in the 1890s because it was the main street running from Baltimore Avenue west to Cobbs Creek.

This 1907 Mercantile Studio postcard is of the southwest corner of 50th Street and Hazel Avenue. The corner house, built c. 1900, has elements of the Arts and Crafts movement in the large roof overhangs and in the use of tile roofs over the porch and bay window. (Courtesy Howard Watson.)

Mailed in 1909, this real photo postcard view of 48th west of Warrington Avenue shows the western edge of this block of large, Queen Anne–style houses in Cedar Park. The block was built in the 1890s. Several blocks to the west, houses built after 1910 changed in style. The Queen Anne–style turrets and picturesque rooflines were no longer in vogue, and the houses became more modest in size.

A new style of house design emerged c. 1910, as seen at the southwest corner of 49th and Warrington Avenue. They were designed in the latest Colonial Revival style—symmetrical in design, with detailed porches, railings, and a sleeping porch. Curious children would love to have their picture taken. They would often follow the postcard photographer around, and he would include them in the images to increase their marketability.

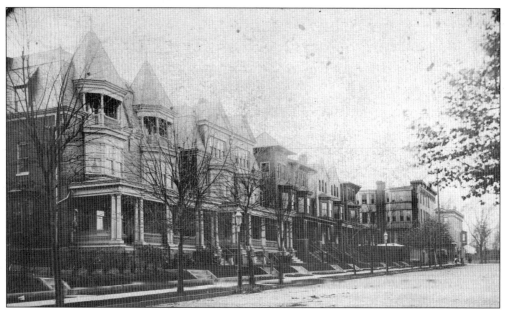

These views from 1907 show 45th Street northwest from Chester Avenue (above) and 45th Street and Chester Avenue (below). Developer George G. Henderson built these large twins homes *c*. 1893. The Queen Anne–Colonial Revival style seen here was his signature design, and there were many blocks of this same design built in Cedar Park. They were built as the trolley lines extended west on Chester Avenue. After 1910, the area west of Cedar Park was developed with modest two- and three-story row houses, as new blocks were further subdivided, making it more profitable to build more homes. (Courtesy Howard Watson.)

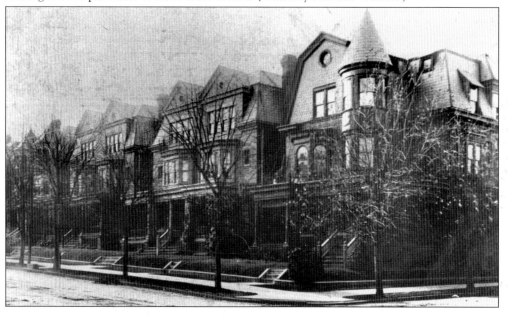

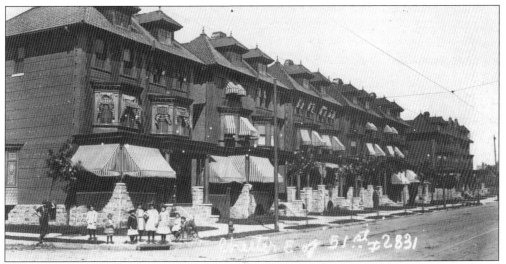

This *c.* 1908 postcard shows Chester Avenue east of 51st Street at the extreme western edge of Cedar Park. The houses are some of the largest houses to be built in the area. The builder targeted them toward an upper-middle-class clientele, who obviously preferred the prestige of living on a wide avenue and the convenience of a trolley stop at their front door.

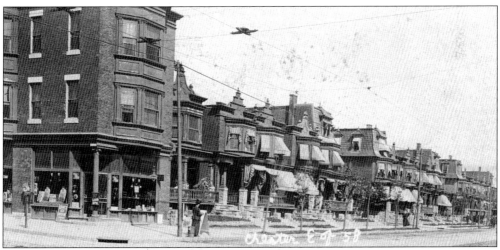

This 1908 postcard shows Chester Avenue east of 58th Street. These newly constructed houses west of Cedar Park are now more modest in design with corner stores at the major intersections. Chester Avenue's long blocks were now intersected by smaller streets, providing developers the opportunity to build more houses. This abrupt change in the size of West Philadelphia's housing could have been caused by an economic depression in 1907.

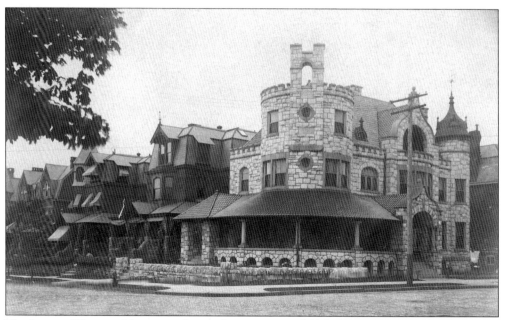

The home of Hansom Haines, at the northwest corner of 48th Street and Springfield Avenue, is shown c. 1907. Designed by architect Charles Balderston in 1902, the castle-style house was unlike any of its neighbors or, in fact, any other in Philadelphia in its use of stone, a bold curved-corner facade, and chimney design. The house has been restored and is again a private home.

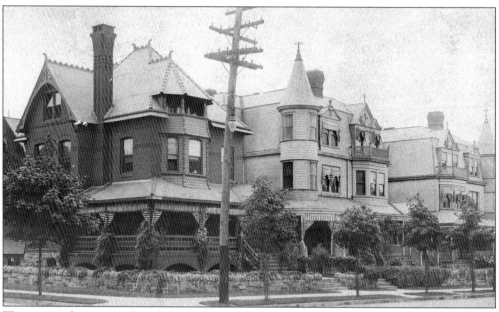

This postcard was posted on July 4, 1910, and features a view the southwest corner of 48th Street and Springfield Avenue, opposite the Haines house. These large Queen Anne–style houses, built c. 1890, are in an architectural style typically representative of Cedar Park houses of that period. The house's porch is fashionably decorated with striped awnings and vines climbing up the porch columns.

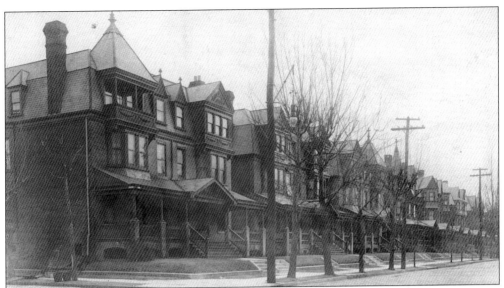

This 1907 photo postcard offers a view of the 47th Street and Springfield Avenue, looking west from 47th. These very large twin houses are still standing today. The opposite end of the block is seen below.

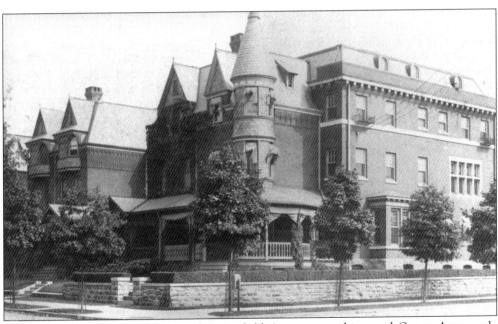

At the southeast corner of 48th and Springfield Avenue was this grand Queen Anne–style house, built in the 1890s and later enlarged, as seen in 1907. The houses were set above the street level, enhancing their already impressive presence. The street is immaculate with newly planted trees and neatly clipped hedges. The house is still standing today. (Courtesy Howard Watson.)

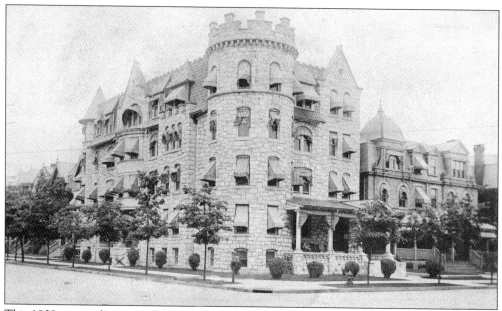

This 1909 postcard view is of the Stonehurst Apartments, built c. 1900 at the southeast corner of 48th and Warrington Streets. The architect, A. Lynne Walker, took a design for a Romanesque Revival–style home and enlarged it, adding additional stories to come up with unusual design. It looks the same today with the exception of a three-story Colonial Revival porch in place of the one-story porch shown here.

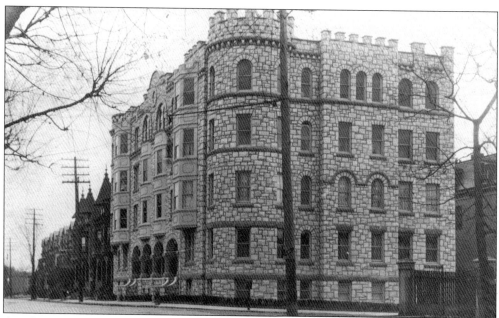

Another stone-castle design, the Sedgley Apartments, located at 45th and Pine Streets, are shown c. 1909. At the turn of the century, West Philadelphia became increasingly developed, resulting in rising property values. This encouraged the construction of apartments rather than houses on the more expensive prime corner lots, where there was more street frontage.

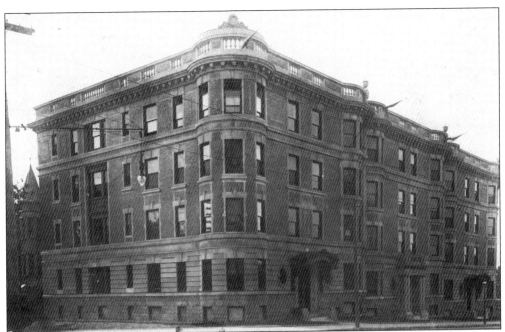

The Netherlands Apartments, at 43rd and Chestnut Streets, are shown in a postcard sent in December 1909. Unlike the Cedar Park's apartment buildings that were designed to look like stone castles, the Netherlands building was constructed in a more modern, Beaux-Arts style. The rounded corner bays gave tenants great views up and down Chestnut Street. The building is still standing today.

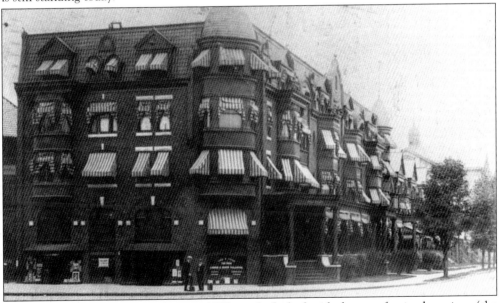

The Ivan Apartments, shown here c. 1907, are bedecked with dozens of striped awnings (the Victorian way of keeping cool before air conditioning). The Ivan building, located at 47th Street and Baltimore Avenue, was designed to look like a row of elegant Queen Anne–style row houses with balconies and porches facing on residential 47th Street. On Baltimore Avenue (its commercial side), the Ivan had basement stores. (Courtesy Howard Watson.)

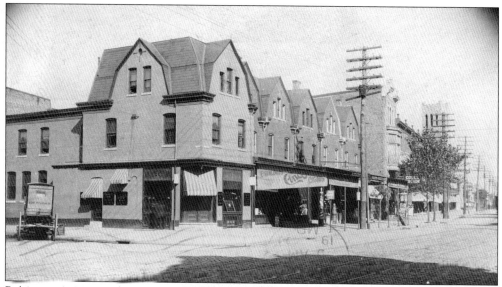

Baltimore Avenue is shown in a 1907 view looking east from 51st Street. The trolley car on the extreme right connected Cedar Park with Angora Mills to the west and Center City to the east. On the corner store was a bar that advertised fine wines and Baltz beer. The sidewalk awning advertises, "Eisenlohr's Cinco Cigars." Next door is a hardware store, and beyond Coll's Arcade is a pool hall.

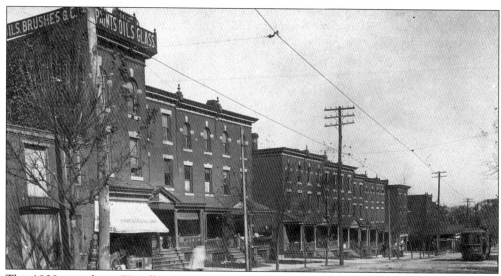

This 1908 view shows Woodland Avenue east of 47th Street. Woodland Avenue was originally called the Darby Road because it went to Darby, Pennsylvania. The avenue, a major commercial street, ran parallel to the railroad tracks and was the southern edge of Cedar Park. Woodland Avenue was a street of modest row houses mixed with commercial enterprises like the paints, oils, and glass store at 4627 Woodland Avenue.

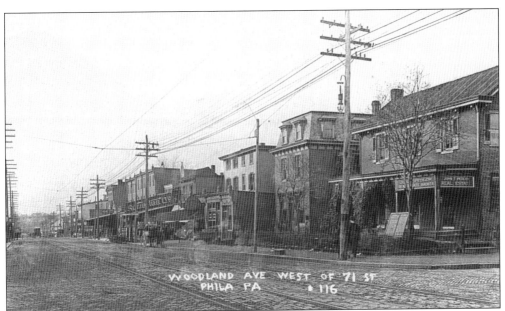

By 1908, cobblestoned Woodland Avenue was built-up all the way past 71st Street and was a major streetcar and commercial road. The architecture of the houses shows that they date from the late Colonial period, such as John Pedlow's real-estate office in the foreground, to the post–Civil War period, as shown in the neighboring Italianate and mansard-style buildings. The sidewalk canopy advertises the Acme Tea Company. (Courtesy Dennis Lebofsky.)

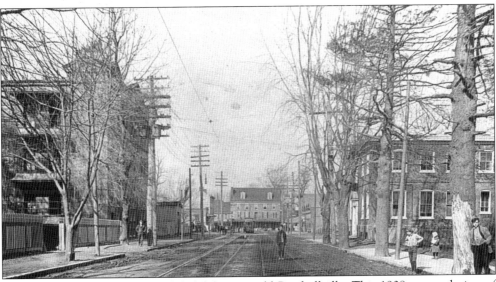

On the western edge of West Philadelphia was old Paschallville. This 1908 postcard view of Island Road shows the historic Blue Bell Inn at the end of Island Avenue, where the road intersects with the Old Darby Road (Woodland Avenue). Running behind the Blue Bell Inn was Cobbs Creek. When this postcard was made, the inn was already over 100 years old. The Fels Naphtha Soap Factory, started in 1901, is shown on the left. (Courtesy Dennis Lebofsky.)

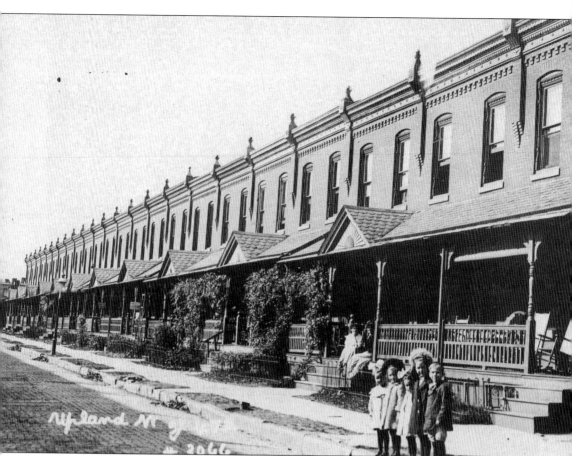

Little Upland Street was located one block north of Woodland Avenue and west of 47th Street. It is shown here in a 1908 real photo postcard. Upland ran for only one block, ending at the Pennsylvania Railroad tracks. These row houses were similar in design to those designed by architect E.A. Wilson. His design was widely published in a 1891 *Harper's Weekly* article on a typical Philadelphia row home. At the turn of the century, these simple and inexpensive houses provided comfortable workers' homes that were the envy of New Yorkers living in crowded, unhealthy tenements and beyond the dreams of the European working classes. By the late 20th century, these small West Philadelphia streets (jammed with automobiles and plagued with abandonment and crime) have lost the innocent charm and pride of ownership they once had.

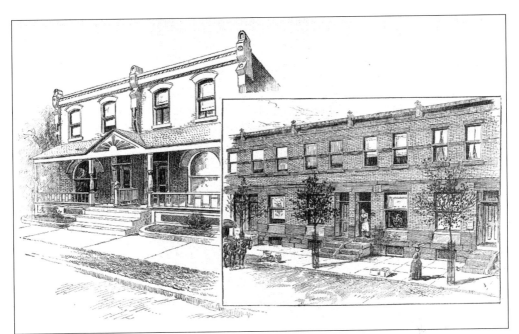

In 1891, *Harper's Weekly* published these designs for a typical Philadelphia home (above). The designs were built all over West Philadelphia on the smaller side streets. The one to the right in the above image is similar to the design of the Philadelphia model house designed by architect E.A. Wilson and exhibited at the World's Colombian Exposition of 1893. Wilson's model house plans are shown in the image to the right. These workers' homes rented from $12 to $23 per month with all the modern conveniences, including central heating and indoor plumbing. It was such a progressive design for working-class housing that was the envy of the 19th-century industrial world. From 1887 to 1893, more than 50,200 two-story houses of similar design were built in Philadelphia. In 1889 alone, some 7,400 new homes were built, an incredible number of new houses built in one year.

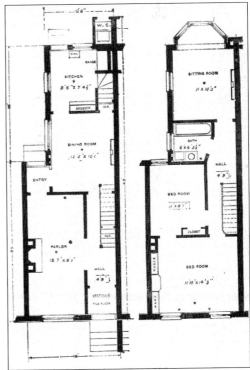

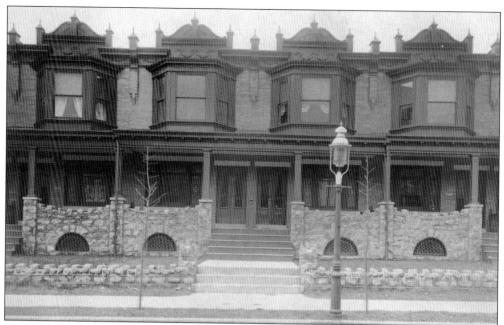

Above is the generic West Philadelphia house design. This design begins around 50th Street and continues west and in all directions for many blocks. The Colonial-style decorative pediments are made with pressed tin to give the houses a more impressive facade. The homes sold for about $4,000 and were designed by architect E.A. Wilson, who designed 20,000 developer houses in a variety of sizes but all similar in design. Below is a 1907 postcard view of the newly constructed 5100 block of Walton Street, built in the generic house design a year before by developer James A. McLaughlin. In the middle of the block is the sign for the sample house: "Open for inspection by owner Louis E. Schner."

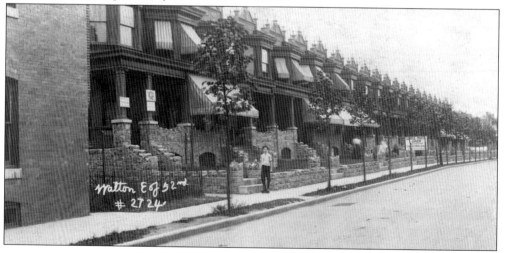

This *c.* 1910 image shows 5113 Hazel Avenue. It is typical of the new upscale houses being built in Cedar Park and Spruce Hill *c.* 1908–1912. (Courtesy Dennis Lebofsky.)

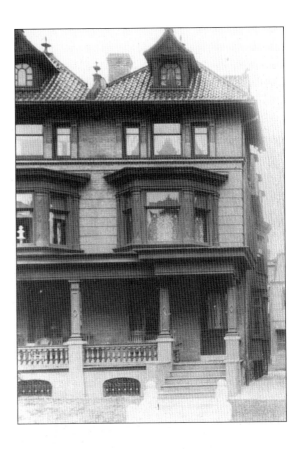

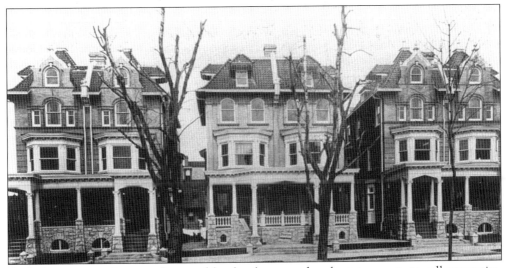

Real photo postcards were often used by developers and real-estate agents to sell properties. These new twin houses on Walnut Street west of 45th Street were constructed by C.H. Charlton, builder and agent. They are shown in a Mercantile Studio postcard dated August 28, 1910. The empty windows indicate that he had just finished these large houses and that they were ready to go on the market. (Courtesy Dennis Lebofsky.)

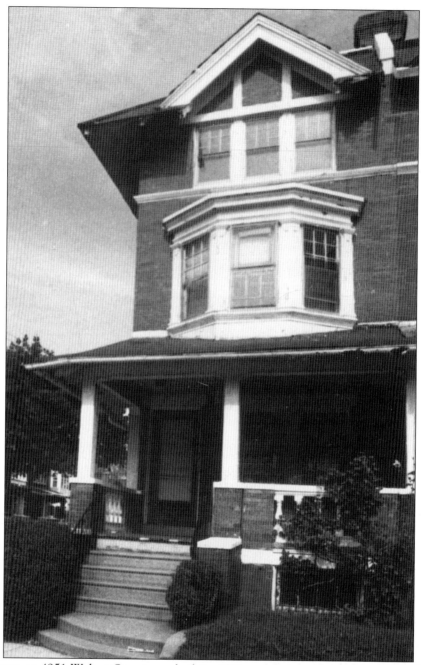

This house, at 4951 Walnut Street, was built in 1911 and designed by architect E.A. Wilson. What makes it unique in West Philadelphia history is that it was the retirement home of Paul Robeson, who lived there with his sister Marian Forsythe from 1966 to his death in 1976. For his steadfast commitment to his social conscience, Paul Robeson—activist, scholar, athlete, and world-renowned singer—was shunted from the center of America's cultural stage. For a generation, his memory was obscured and his achievements forgotten. Today, Paul Robeson's rich legacy is again appreciated. The Paul Robeson House is a museum to his memory and is a National Historic Landmark.

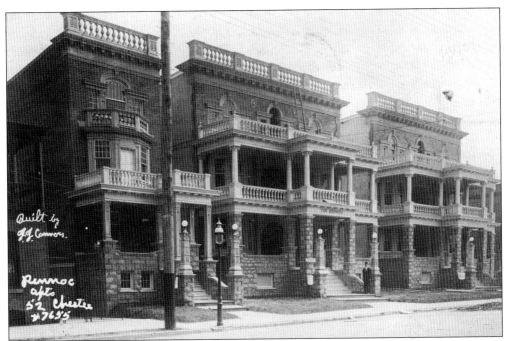

The Rennoc Apartments, located at 52nd Street and Chester Avenue (above), and the Regent Rennoc Apartments, located on the 5100 block of Regent Street (below), are shown in these 1910 postcards. The apartments were completed that year by developer Joseph Connor. The architect was the prolific E.A. Wilson, whose designs can be seen all over West Philadelphia. Both apartment buildings were designed in a Colonial Revival style, with Palladian arched windows, classical balustrades, and colonnaded porches opened on three sides for ventilation. By the late 1980s, all the apartment buildings were derelict and near collapse. Fortunately, they have been restored to their 1910 appearance, thanks to the Historic Tax Credit Act.

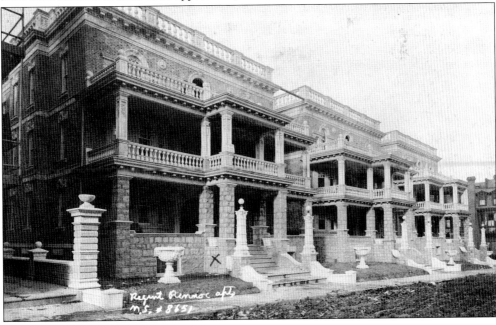

This 1905 image shows Whitby Hall, located on 58th Street between Baltimore Avenue and the Darby Road. Whitby was built in 1754 by American Revolution merchant James Coultas and was visited by George Washington. The mansion gave its name to Whitby Avenue, which was opened in 1890. It was one of many Colonial buildings still standing in West Philadelphia at the turn of the century. At that time, however, West Philadelphia's historic structures (except for those Colonial mansions in Fairmont Park) were in peril of being demolished by the rapid advance of new developments. In order to preserve Whitby Hall, it was taken down brick by brick in 1922 and relocated, thus saving it for future generations. Whitby Hall stands today, not on its original site, but in suburban Haverford, Pennsylvania.

Three

POWELTON

The Powelton Village historical district is bordered by Lancaster Avenue on the south, the Pennsylvania Railroad to the east, and Spring Garden Street to the north. North of Powelton Village is the neighborhood of Mantua, and to the west is Belmont.

Early in the 19th century, Powelton Village began to develop in a modest way when a pioneer suspension bridge was built in 1840 across the Schuylkill River below the waterworks dam. In the 1860s, the Race and Vine streetcar line crossed the bridge and ran on Bridge Street, now called Spring Garden Street. Powelton Village was now connected by horse-drawn streetcars to Center City, and it began to expand westward from the Schuylkill.

One can roughly date a house in Powelton by its style. The Italianate style identifies the earliest houses built in Powelton Village. This houses, many with cupolas and towers, were built in the 1860s on lower Baring, Hamilton, and Spring Garden Streets. In the 1870s, fashionable Second Empire–style houses were built on Hamilton and Baring Streets. By the late 1880s, many executives of the Pennsylvania Railroad and Baldwin Locomotive Works made Powelton Village their home. They built extravagant architect-designed Victorian mansions in the various styles—Queen Anne, Romanesque, German Gothic, and (later) Colonial Revival. Powelton Village even had a special railroad stop at Powelton Avenue for the Pennsylvania Railroad's executives to travel by train to their offices. Powelton Village was also known as the home of the Presbyterian Hospital, founded in 1871. The hospital was built on the site of Dr. Courtland Saunder's mansion, located on an entire city square from Powelton Avenue to Filbert Street and from Saunders Avenue to 39th Street. The hospital's growth greatly added to the development of Powelton Village. As the 20th century began, apartment houses were being built in Powelton but to a lesser extent than in University City at that time, thus keeping much of Powelton's suburban ambiance intact.

On the south side of the 3200 block of Spring Garden Street stood this large twin Italianate villa. It was built prior to 1872, when Spring Garden Street was called Bridge Street. By 1908, when Mercantile Studio photographed this building, the twin houses had been combined into the Spring Garden Apartment House. At some point, the yard on the west side of one of the houses was sold to build a new Queen Anne–style twin house.

The Italianate style identifies the twins to be one of the earliest houses built in Powelton Village, probably dating from the 1860s. The style of these houses suggests that of 19th-century carpenter John Riddel. The building had a cupola that must have offered its owner a great view of the Schuylkill River and Center City. As was the fashion in the 19th century, the wrought-iron supports of the porch were covered with climbing vines. Similar style houses were also built in University City on historic Woodland Terrace, and in the Belmont area on Preston, Ogden, and North 40th Streets. (Courtesy Dennis Lebofsky.)

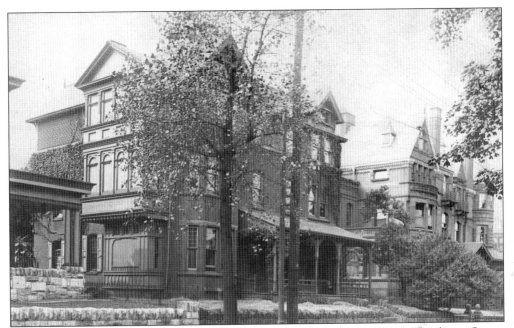

This view of North 33rd Street at Powelton Avenue dates from 1905. The large Queen Anne–style mansion shown here was built in the late 1880s. It was torn down in the late 20th century by the Drexel Institute. To the right is the Poth mansion, also seen below.

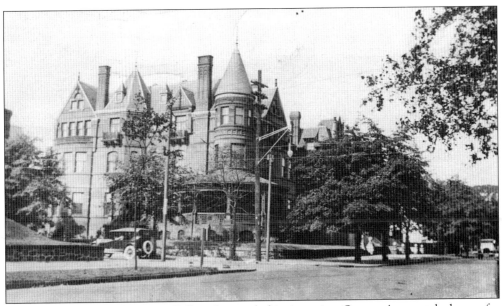

In 1887, architect Albert W. Dilkes designed this imposing Queen Anne–style house for Frederick Poth. The style, sometimes called "German Beer Baron Gothic," was popular in the late 1880s. Poth appropriately owned a large brewery and was a real-estate developer who built apartment blocks in Powelton. The Poth house, located at the corner of 33rd Street and Powelton Avenue, survives today as fraternity house. This postcard was made c. 1920.

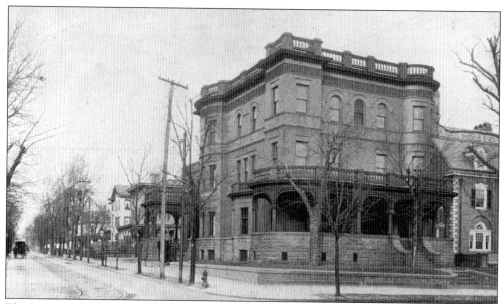

The home of Harrison Dickey Stratton was located at the northeast corner of 35th Street and Powelton Avenue. Stratton was an engineer, inventor, and manufacturer of ice-making machinery. His home of was described in *King's Views of Philadelphia* as being "in a most eligible location of a choice residence thoroughfare, amid beautiful homes." The Colonial Revival house shown on the right is still standing; the Stratton house is not.

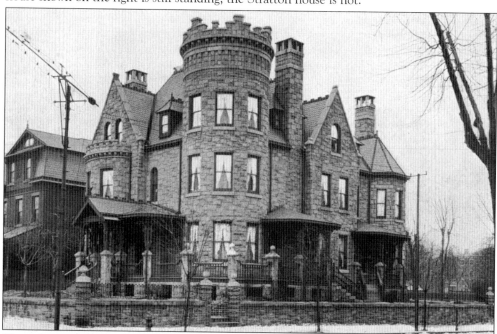

This photograph from *King's Views of Philadelphia* shows Patricius McManus's castlelike residence, located at the southeast corner of 36th and Baring Streets. McManus was a general contractor who constructed roads, bridges, and railroads. The McManus family eventually moved from this house because they felt it was too small and lacked a ballroom. The house became a nunnery, a fraternity house, and once again a private residence.

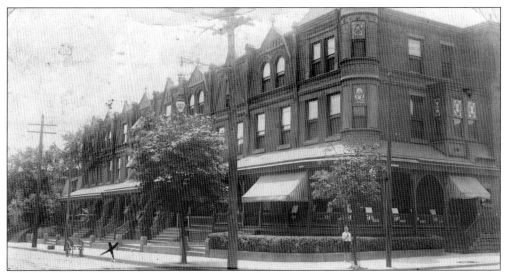

The southwest corner of 33rd and Spring Garden Streets is shown as it looked in 1908. The corner house had beautiful stained-glass windows and an elaborate wraparound porch that made this house unusual. The Race and Vine streetcar line ran on Spring Garden Street past the corner that was the northern edge of Powelton.

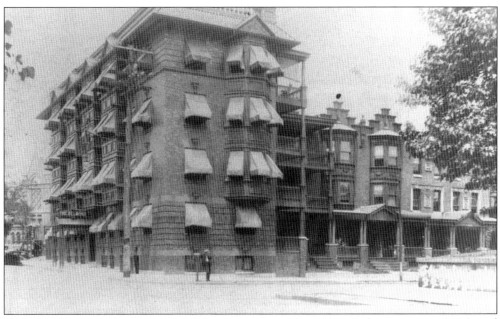

This c. 1908 image shows the new Belmont Apartments, at the southeast corner of 34th and Spring Garden Streets. Often, the ends of blocks were developed for apartments. The upper floors of the Belmont Apartments must have had a wonderful view of Center City. In the background, the facade of the 34th Street Baptist Church at Brandywine Street is faintly visible.

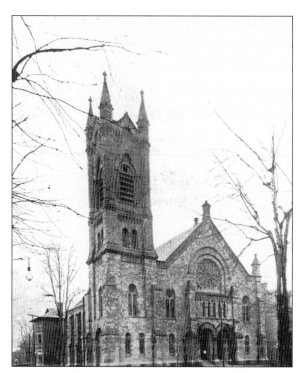

This image from *West Philadelphia Illustrated* (1903) is of the Northminster Presbyterian Church, originally the First Presbyterian Church of Mantua, dating from 1837. The church was built at 35th and Baring Streets in 1879. It was the last recorded project of architect Thomas Richards, who also designed the University of Pennsylvania's Logan Hall and College Hall. The beautiful Gothic-style church is now the Metropolitan Baptist Church.

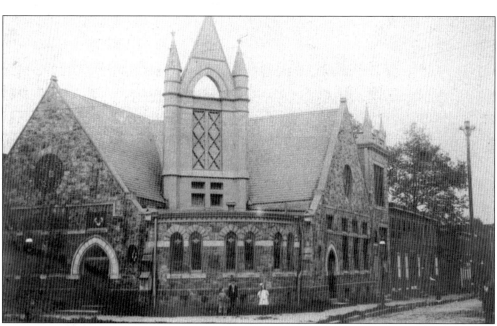

Shown c. 1907, the 34th Street Baptist Church was built in 1893 at 34th and Brandywine Streets. The church's architect, Charles Bolton, came up with this unique design of placing a tower in the middle of the crossing. As the congregation grew, architect Adin Lacey was hired in 1901 to make additions and alterations to the church. The building is now the New Hope Primitive Baptist Church.

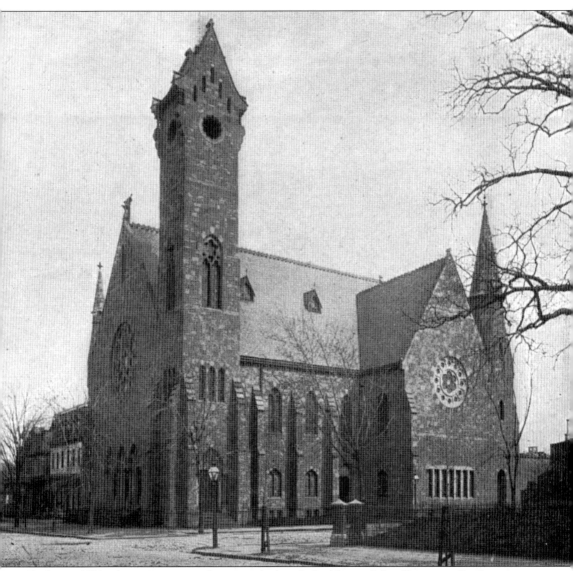

Built in 1889, this structure is the second church building of the Princeton Presbyterian Church. The architect was Albert W. Dilks, who designed this unique church with an impressive German Gothic tower. The donor of the land at Powelton Avenue and Saunders Street, right across from the Presbyterian Hospital, was Sarah Miller from Princeton, New Jersey. The congregation originally wanted to name the church Miller Presbyterian Church, but Miller modestly declined and suggested Princeton instead. In 1954, the congregation relocated to Baltimore Pike in Springfield, Delaware County. The building is no longer standing. This photograph is from *West Philadelphia Illustrated* (1903).

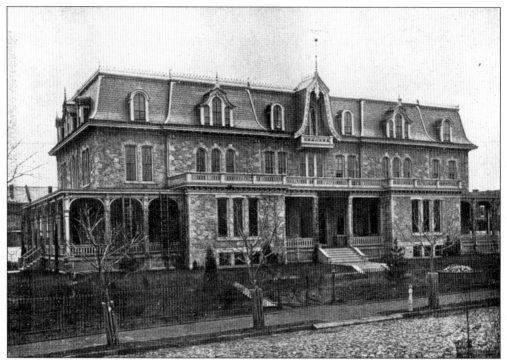

Designed in 1897 by the Hewitt Brothers architects, the Old Man's Home was located on Powelton Avenue between Saunders Avenue and 39th Street. The large stone building was designed to look like a fashionable Second Empire mansion with large porches for the "old men" to sit and rock and enjoy the well-landscaped grounds. This photograph is from *West Philadelphia Illustrated*.

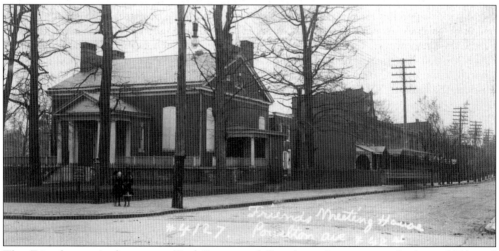

The Friends meetinghouse, at 42nd Street and Powelton Avenue, was built in 1901 and designed in a Colonial Revival style by the architectural firm Bunting and Shrigley. It sat in sharp contrast to the Victorian-styled homes, churches, and institutions in that area. The meetinghouse still stands today.

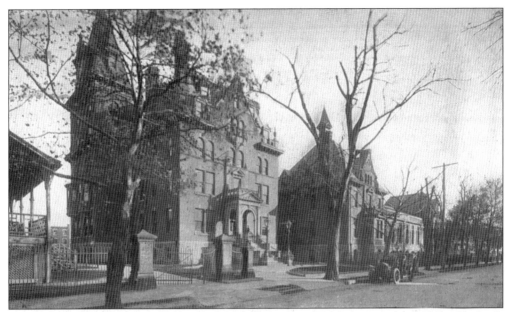

This postcard view of the administration building of the Presbyterian Hospital (at 51 North 39th Street) was made *c.* 1910. The building, with its elegant entrance drive, was built *c.* 1878. The hospital was located on the site of the mansion of Rev. E.D. Saunders, who gave the land and founded the Saunders Institute. Saunders Avenue also bears his name.

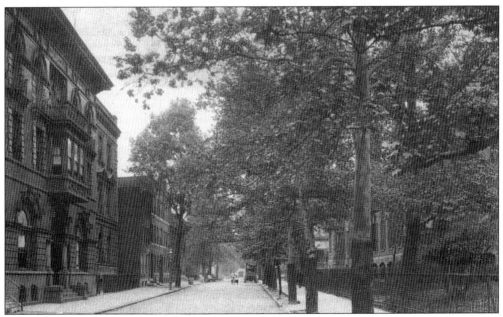

The nurses' home of the Presbyterian Hospital (left) was built in 1899 and was designed in a Renaissance Revival style by architect Charles Bolton, who is credited with designing more than 500 churches across the county. The building was very elegant for a nurses' residence. This 1910 postcard view is looking north on 39th Street.

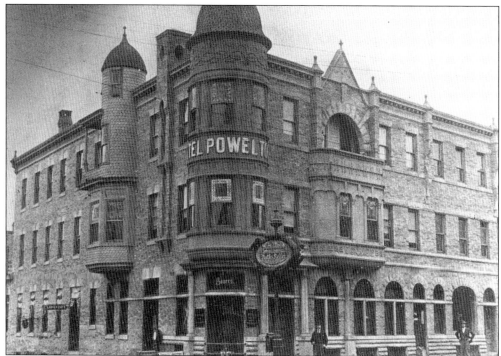

The *Office Building Directory* of 1899 displayed this photograph of the Powelton Hotel, located at the northwest corner of 40th and Filbert Streets. The owner, Charles Sauers, ran a hotel that was for men only. On the ground floor was a Raths Keller, which later became the Powelton Café. A discrete ladies' entrance was on the Filbert Street side of the building.

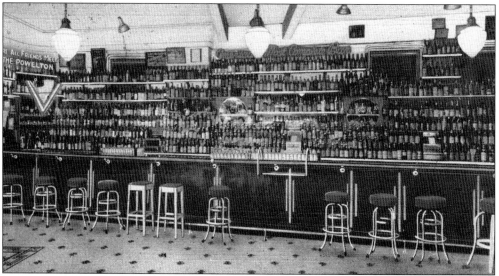

By the 1930s, the old Raths Keller had become the Powelton Café, advertised as "America's Most Complete Bar," as seen in this 1930s postcard. The postcard's back advertised that the Café featured 2,800 assorted liquors, wines, brandies, and beers from all over the world and live entertainment, with two shows nightly at 10:30 P.M. and 1:00 A.M. The Powelton Cafe was obviously no longer a quaint little oyster bar selling German beer.

Four

THE NEW MARKET STREET ELEVATED LINE

On September 23, 1905, a convention of the American Street Railway Association was held in Philadelphia. The *Street Railway Journal* was published for the convention, expounding the achievements and goals of the Philadelphia Rapid Transit Company (PRT) under the direction of its dynamic president, John B. Parsons. Under construction was his greatest achievement, the Market Street subway-elevated line. With all the necessary franchises acquired by the PRT, a broad scheme for building a rapid-transit facility in conjunction with existing surface lines was formulated. Anxious to demonstrate the feasibility of the plans and to afford the much needed relief for the badly congested surface lines (particularly on Market Street), the PRT decided to build the first section of the rapid transit line in West Market Street. The first section commenced as a subway at the west side of City Hall in front of the Pennsylvania Railroad Broad Street Station and ran under Market Street due west to the Schuylkill River. From that point, it went by a bridge over the river and continued as an elevated structure on Market Street, ending at 63rd Street.

The elevated line was built primarily to serve the new sections of West Philadelphia, which in 1905 were becoming some of the city's chief residential districts. The secondary purpose was to relieve East Market Street's surface congestion in conjunction with a subway loop in Center City. The PRT hoped to improve transit traffic in Center City by a whopping 230 percent. Their plan was to move 9,000 passengers per hour with six-car subway trains seating 50 passengers per car and moving at two-minute intervals between trains. When the Market Street subway-elevated line opened in 1907, it caused a building boom in West Philadelphia. West Philadelphia soon developed into a middle-class commuter suburb, with most of the new residents either "old stock Americans or of Irish or German descent," and new row houses being built as far west as 63rd Street. Major shopping districts developed at the elevated stops at 40th, 52nd, and 60th Streets. In a few years, once-open farmland became a home to thousands of average Philadelphians.

This 1906 view of the sunlit northwest corner of 38th and Market Streets was made before the Market Street Elevated was built. There is a pharmacy shown on the corner. Nearby is the classical-styled Philadelphia Horse Exchange, opened in 1876 by Michael Sullivan. The opening of the Market Street Elevated in 1907 caused this area to develop into a major commercial center. Because of the elevated line's structure, the sun would no longer shine down on this corner until years later, when this section the Market Street Elevated was replaced by a subway. The elevated was both a blessing and a curse. It greatly improved transportation but changed the character of all of West Market Street into a dark, shadowed, and noisy street.

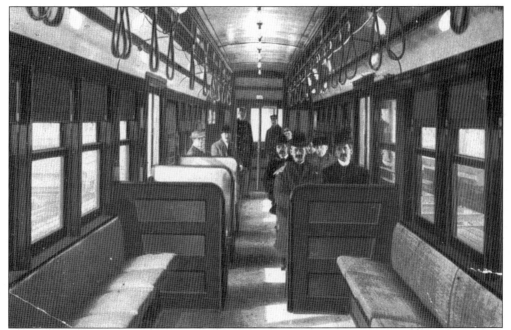

In 1907, the Market Street Elevated opened, taking passengers to and from Center City in the comfort of the wooden elevated train cars shown in this 1908 postcard. The car's seats were made of woven rattan, and the hanging straps were made of leather. The cars were designed to seat 50 passengers. Elevated stations at 40th, 52nd, 60th, and Market Streets resulted in those intersections becoming major commercial centers.

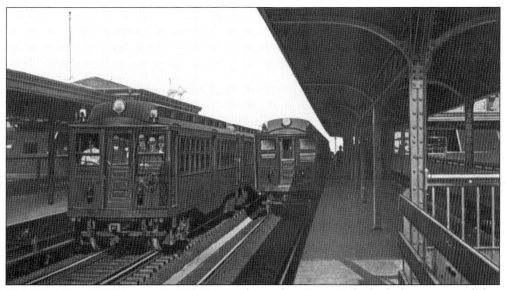

This view from 1907 shows the 40th Street elevated station as it looked when it opened that year. This was high-tech stuff then and greatly improved the ability of the average West Philadelphia resident to commute to work in comfort and shop at new commercial areas that opened at the elevated stops, as well as Center City.

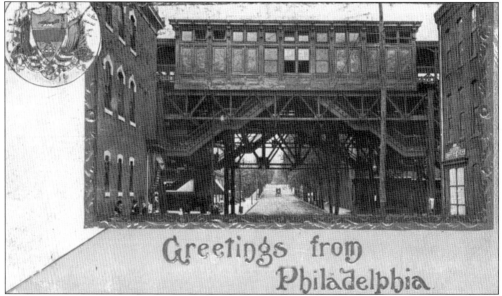

Greetings from Philadelphia

This decorative postcard from 1909 shows the station at 40th and Market Streets. Although most of West Philadelphia was developed for housing, the elevated also opened it to industry. The Fels Naphtha Soap Company and Angora Mills were already in West Philadelphia, soon to be followed by General Electric, the ACF Brill Company, Breyers Ice Cream, the Prudential Insurance Company, and the Chilton Press—all of which provided jobs for thousands of people.

This postcard, printed c. 1910 by the Chilton Printing Company, features the company's new printing plant at 49th and Market Streets. The back of the card invites one to inspect this modern "daylight" plant, lighted by a roof full of skylights. In keeping with the modern theme, the postcard also features the new Market Street Elevated, an electric trolley car, an automobile, and a delivery truck. (Courtesy Dennis Lebofsky.)

90

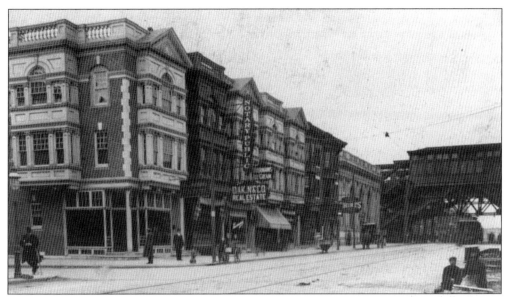

Shown c. 1909 is the west side of the 100 block of South 52nd Street (the newest business district in West Philadelphia), built at the 52nd and Market Street Elevated stop. The signs read, "Bacharach's Quality Shirts," and, "DAK.N & Co, Real Estate." This new row of stores was designed in the latest Colonial Revival style with Palladian windows. (Courtesy Howard Watson.)

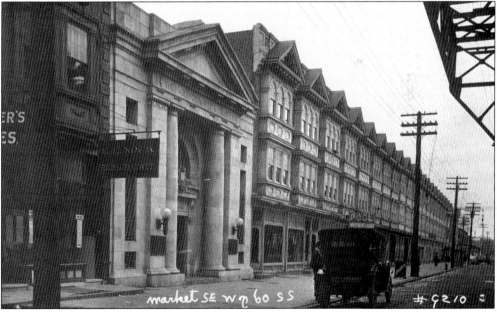

By 1910, endless rows of stores were built on Market street, as shown in this postcard view of the southeast corner of 60th and Market Streets at a new elevated stop. Large, imposing, classical-style banks were also built at every elevated stop; the one shown here is the Haddington Title and Trust.

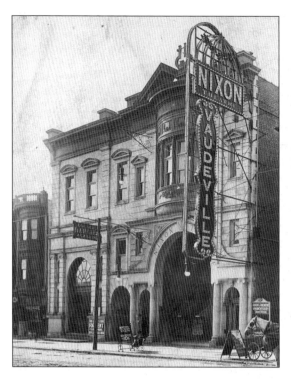

Vaudeville matinee tickets were only 10¢ when the Nixon Theater, at 28 South 52nd Street, opened on November 21, 1910. Fifty-second Street was a popular theater street. The Locust Theater opened in 1914 at 52nd and Locust Streets. Also in 1914, the Belmont Theater opened at 25 North 52nd Street. The magnificent State Theater, at 52nd and Chestnut Streets, opened in August 1929. Today, only the Locust Theater still stands.

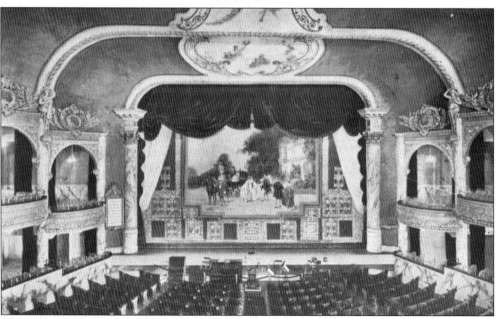

This 1911 postcard shows the imposing interior of the Nixon Theater, with its elaborate painted fireproof curtain and box seats. The theater seated 1870 people and had a nine rank Moeller organ. Because of new theaters like the Nixon, built after the Market Street Elevated opened, West Philadelphians no longer had to travel to Centre City for entertainment. The Nixon was torn down in 1985.

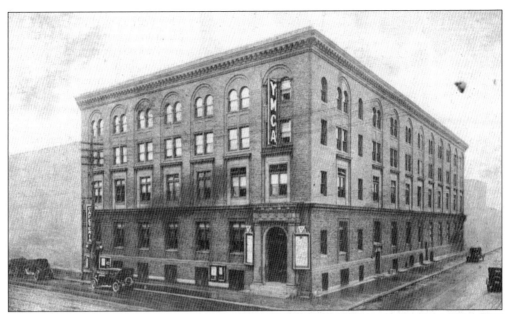

The new west branch of the YMCA, located at 115 South 52nd Street, is shown c. 1915. The sign on 52nd Street is for the YMCA cafeteria. By 1915, automobiles were becoming commonplace in postcard views of West Philadelphia. The building is no longer standing.

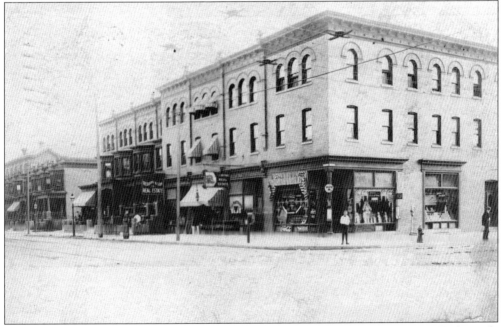

This postcard of the southwest corner of 52nd and Spruce Streets was sent in 1907. A candy store occupied the corner, and two real-estate offices were next door. West Philadelphia was in a building boom when this postcard was made, and there were many new houses on the market to keep these real-estate offices busy. The 300 block of South 52nd Street, shown here, is still standing.

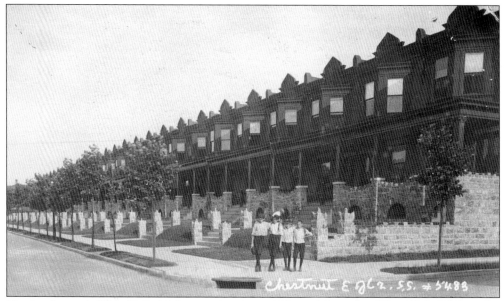

Blocks of generic West Philadelphia row houses quickly proliferated in West Philadelphia after the Market Street Elevated opened. This 1910 postcard shows the south side of Chestnut Street east of 62nd Street. These row houses were not great architecture, but for about $4,000, the average Philadelphian could own a home in a clean, healthy neighborhood at a time when the average New Yorker lived in a tenement apartment.

The Beaucaire Hotel was located 65th and Vine Streets close to the Millbourne Station of the new Market Street Elevated and at the end of Race and Vine trolley line. By 1907, what would have been a long, hot trip by horse and cart could now be accomplished in a short time, making the Beaucaire Hotel readily accessible to those seeking the cool of Cobbs Creek on hot summer days.

Five

BELMONT

Unlike West Philadelphia neighborhoods farther west that sprang up overnight when the Market Street Elevated opened, Belmont grew at the speed of the horsecar lines that connected it to Center City and gave it a quaint village quality. It was this variety of housing stock that made Belmont so interesting architecturally.

The Belmont neighborhood is bounded by 40th Street to the east, 44th Street to the west, the Pennsylvania Railroad to the north, and commercial Haverford Avenue to the south. Lancaster Avenue, the neighborhood's other shopping street, cuts on a diagonal separating the area into two distinct areas, one south and one north of Lancaster Avenue.

The Market Street horsecar line terminated at a large depot at 41st Street and Haverford Avenue on Belmont's southern boundary. By 1869, there were enough residents in Belmont to justify the opening of the Belmont Grammar School. Belmont remained villagelike in character (with Italianate suburban villas and a variety of single and twin houses, some even constructed of wood) until the newly electrified Route 40 streetcar went into service in 1895. Belmont developed as the electric trolley lines headed north to Parkside. By the end of the 19th century, land values increased and most of Belmont was built-up with brick row houses. The new row housing replaced some of the earlier single houses that dated from the 1860s and 1870s. At the turn of the century, Belmont was an economically diverse community, the residents of which included old-stock Americans, as well as the more recent immigrants of German, Irish, or Italian descent. Belmont had many fine churches and institutions, including the Pennsylvania Railroad YMCA, the Pennsylvania Keystone Battery Armory, and the West Philadelphia Hospital for Women. Belmont is fondly remembered by the author as his "old neighborhood."

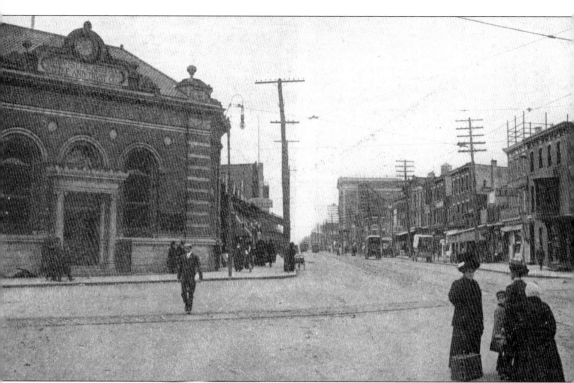

This image of the intersection of 40th Street and Lancaster Avenue is from a publication of the City of Philadelphia that shows all the street improvements made in the year 1910. Lancaster Avenue was a main shopping street. Many stores were owned by people of German descent, for there was a large German population in the area at the turn of the century. The large building seen at the end of the 4000 block is the William Penn Theater. The once elegant West Philadelphia Title and Trust Company, shown above, dominated the 40th Street intersection. In 1902, the bank advertised it had a capital of $500,000. Unfortunately, like many West Philadelphia banks, it went under in the Great Depression. When the West Philadelphia Title and Trust Company closed its doors, a young depositor with $50 in his savings account received a bank check for only 7¢. He promptly used it to buy an ice-cream cone, leaving him with 2¢ change.

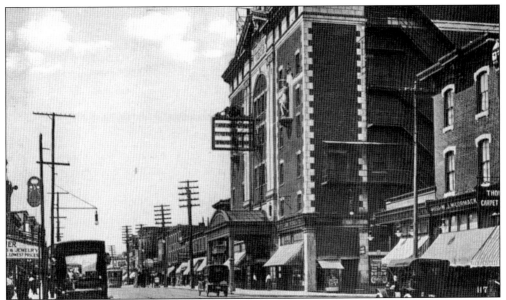

The William Penn Theater was located at 4063 Lancaster Avenue. It opened on September 20, 1909, and seated 3,230 people. This 1912 view shows a vigorous business district on Lancaster Avenue. In the 1920s, the William Penn Theater featured the Mae Desmond players. University of Pennsylvania students would cut classes just to see Desmond's matinee performances. The theater was torn down in 1936 and replaced by a Baltimore Supermarket.

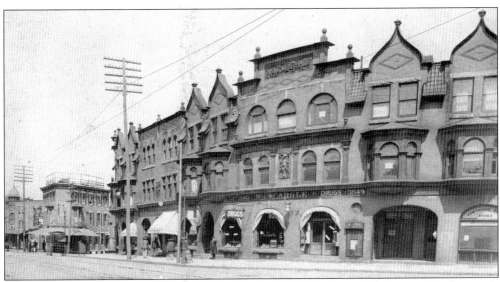

This 1907 view shows the Hamilton Hall, a once elegant commercial-apartment block at 39th Street and Lancaster Avenue. It was built in the 1890s on the site of a former lumberyard. Hamilton Hall's unusual curved, yellow, Roman brick facade and terra-cotta decorations were in the latest the Art Nouveau style when it was constructed. The Hamilton Hall is still standing today.

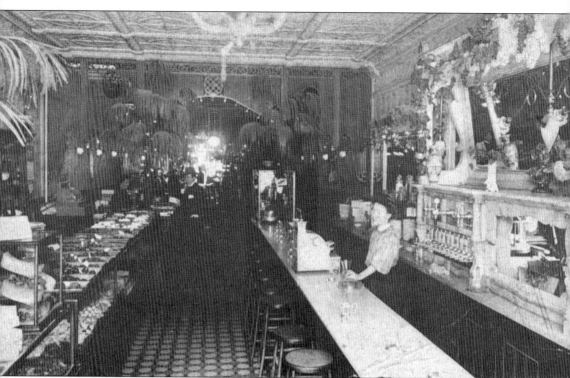

After attending the show at the William Penn Theater, theatergoers might have strolled two blocks west to Furey's, at 4235 Lancaster Avenue, famous for its ice creams, bonbons, and chocolates. This rare 1909 postcard shows the store's elaborate interior with tile floors, pressed-tin ceilings, marble counters, and lots of Victorian bric-a-brac. Also shown behind the counter is a marble soda fountain manufactured in Philadelphia by the Robert M. Green Company. Green invented the ice-cream soda at the 1876 Philadelphia Centennial Exposition and later went into the soda-fountain business. Furey's sweet shop was well located, for three years after this postcard was made, in 1912, the Leader Theater opened only one block east of Furey's at 4102–4104 Lancaster Avenue. The Leader seated nearly 1,000 people, potential new customers for Furey's bonbons.

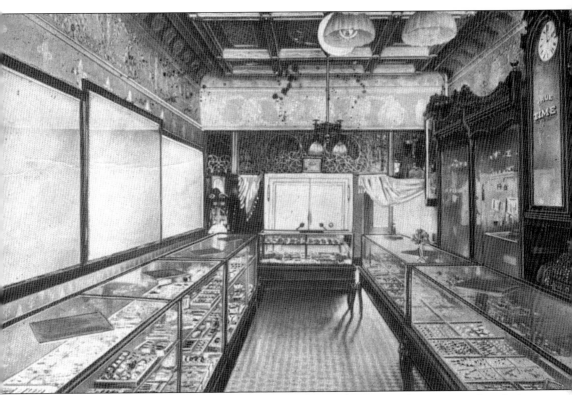

This very rare postcard was sent in July 1913 by Walter Engle to remind a customer that their order was ready. Walter Engle manufactured and sold jewelry in his store, located at 4233 Lancaster Avenue. It was decorated in height of Victorian décor for his upscaled clientele. This area of Lancaster Avenue was developed by German brewer and developer Frederick Poth, and many of the businesses on Lancaster Avenue in 1900 were owned by people of German descent. In the 1930s and 1940s, many of the business on Lancaster Avenue were owned by people of Jewish descent.

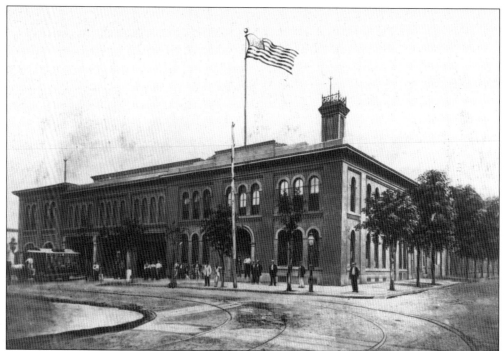

This 19th-century photograph shows the Market Street line depot, located on the northwest corner of 41st Street and Haverford Avenue. The photograph was taken before the streetcars were electrified in 1895. At that time, the depot was the end of the line. The large American flag was added by the photographer to enhance the picture. (Courtesy the Library Company of Philadelphia.)

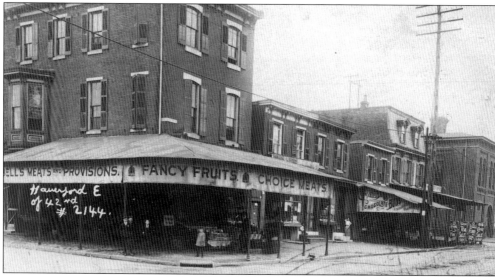

This real photo postcard, made in 1907, shows the 4100 block of Haverford Avenue just east of the streetcar depot. The east end of the depot building can be seen to the right. Haverford Avenue was one of the commercial streets serving the neighborhoods of Powelton and Belmont. Bell's Meats and Provisions, a confectionery, and a grocery store were on this block. Bell's sign advertises that they have "liver today."

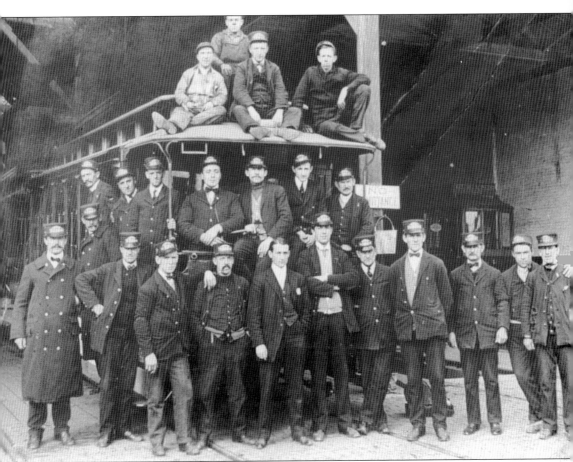

Posing in front of the latest in electric streetcars are the trolley operators and conductors who ran them. They helped make the development of West Philadelphia's streetcar suburbs possible. There were two men on each trolley—the motorman and ticket taker (who was stationed in the middle of the car). If a child was not tall enough to reach the height of the partition in front of the ticket taker, the child rode free. Streetcars were used to deliver mail, and there were even special cars for funerals. The electric streetcar could run at an astonishing 15 miles per hour, making it possible for the average person to live far away from his workplace. Just as the suburban trains had earlier enabled the wealthy to live far away from their factories into the suburbs of Germantown, Bryn Mawr, and Jenkintown, now the middle and working classes could also live removed from the dirt and congestion of the city, thanks to the modern streetcar system.

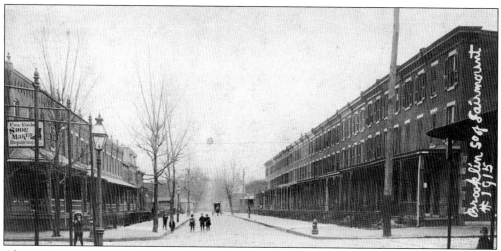

Above is a 1907 postcard view of Brooklyn Street south of Fairmount Avenue. Brooklyn Street, located between 42nd and 43rd Streets, ran north from Haverford Avenue to Lancaster Avenue. This long row of houses was built around the time of the centennial. The sidewalk canopy is for a shoemaker's corner store. The row is no longer standing. Below is a 1907 postcard view of 44th Street south of Fairmount Avenue. The houses were built prior to 1872 and, unlike houses built later, were all not uniform in design. In the mid-19th century, this villagelike area was situated near two horsecar lines, which was why it developed soon after the Civil War. The houses are not standing today. (Courtesy Howard Watson.)

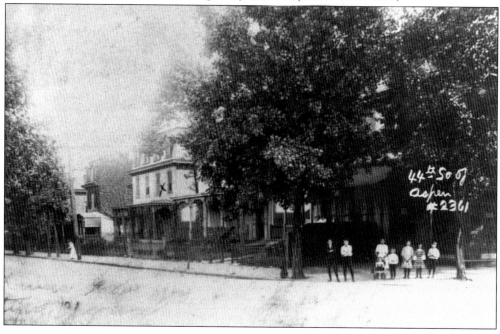

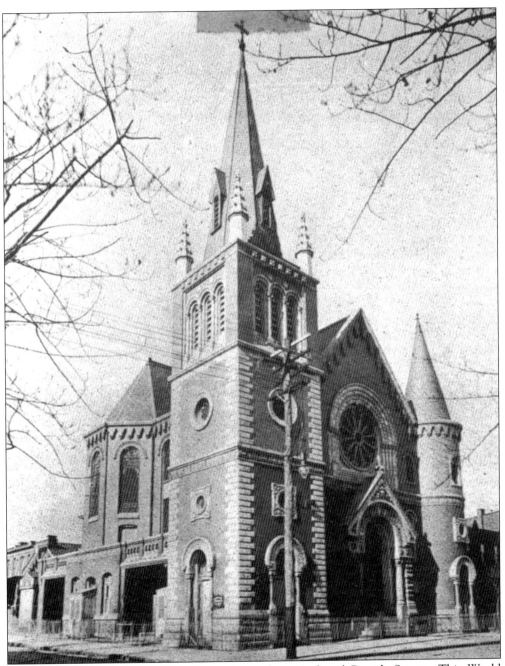

St. Petri German Lutheran Church was located at 42nd and Parrish Streets. This World Postcard Company view from 1905 served as an advertisement from the M.J. Frizlen millinery establishment as 4045 Lancaster Avenue. The congregation, established in 1871, was German-speaking. In 1872, they built a small chapel and, in 1894, hired architect H.C. Hartmann to design this beautiful church building. The church's style was described as a marriage of German and Colonial architecture. In 1950, the congregation left for the Tacony section of Philadelphia, where they merged with another German Lutheran Church. Their new church was renamed St. Petri Evangelical Lutheran Church of Tacony.

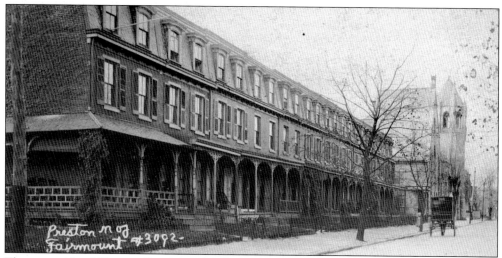

The west side of Preston Street north of Fairmont Avenue is shown c. 1908. The view is looking north on Preston Street. At the north end of the block was the West Hope Presbyterian Church. The mansard-roofed row houses were built c. 1880. They were conveniently located one block from the horsecar line that ran on Lancaster Avenue.

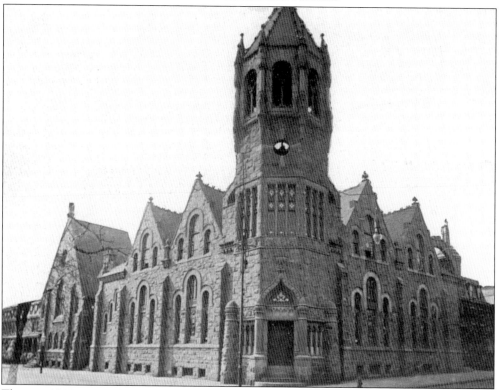

This is a 1908 postcard of the West Hope Presbyterian Church, located at Preston and Aspen Streets. The church, originally called the Mantua Second Presbyterian Church, was founded in 1861. In 1876, the congregation moved to Preston and Aspen Streets. In 1892, the Romanesque church building was erected. In 1948, the West Hope Presbyterian congregation left this building, merging with a church in the Overbrook section of Philadelphia.

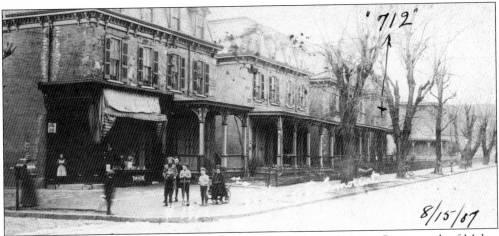

These views—the 700 block of North 42nd Street (above) and Union Street north of Melon Street (below)—date from 1907. The two streets were located only a few blocks apart, as Union Street ran between 39th and 40th Streets. Both blocks were similar in design—twin homes with mansard roofs, dating them from about the time of the Philadelphia Centennial Exposition. The blocks were likely built by the same developer using a single floor plan. They were built as the horsecar lines extended west on Haverford and Lancaster Avenues, linking Belmont with Center City. Union Street and North 42nd Street had streetscapes typical of a late-19th-century streetcar suburb with wrought-iron-fenced front yards, porches, cobblestone streets, gas street lamps, trees, and brick sidewalks.

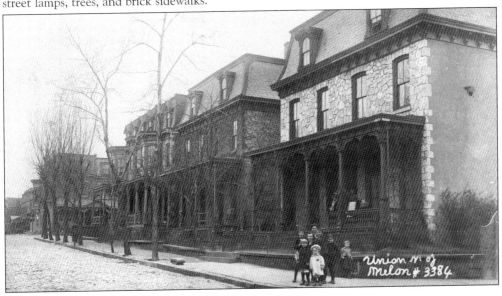

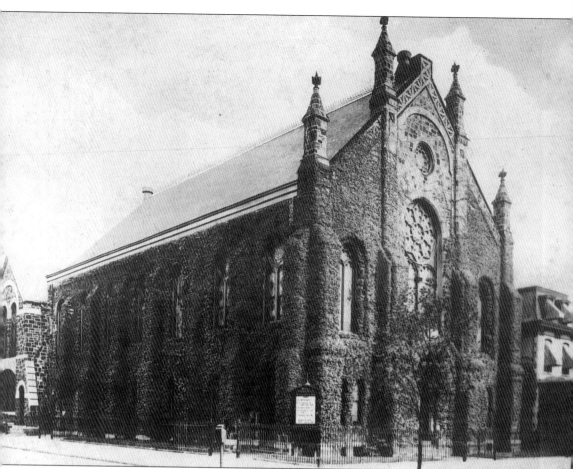

The Mantua Baptist Church, at 40th Street and Fairmont Avenue, is pictured in a postcard from 1908. The building, erected in 1888, was designed by architect Isaac Pursell in a Gothic style. The church established missions at Belmont and Westminster Avenues and at 40th Street and Girard Avenue. At the time, the area around North 40th Street had several blocks of mansard-roofed twins and architect-designed single houses, such as the house shown to the right of the church. The church had a disastrous fire c. 1950. Soon after the fire, the building was further damaged in the rebuilding by a contractor who used cheap concrete block instead of stone to repair the upper half of the church's fire-damaged stone facade.

To the right is the Calvary Protestant Episcopal Church (located at 814 North 41st Street, north of Brown Street), shown *c.* 1908. Built sometime after 1872, the church is an offshoot of an earlier congregation located in Northern Liberties in the 1840s. Below is a sketch made by the author of his family home at 871 North 40th Street in Belmont. The house was built in the mansard style after the 1876 Philadelphia Centennial Exposition, and a store was added *c.* 1915. Like most West Philadelphia corner shopkeepers, the family lived above the store, and all the family members helped with the chores.

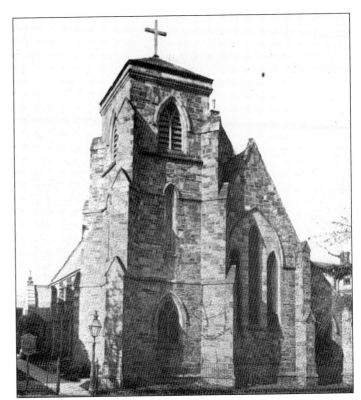

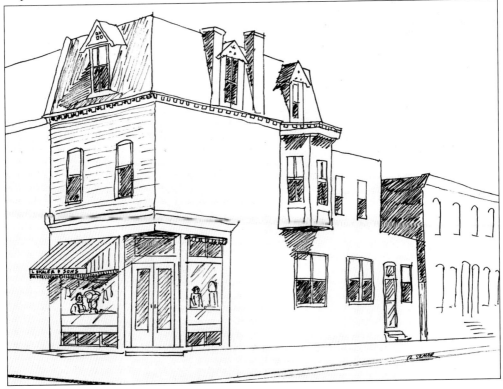

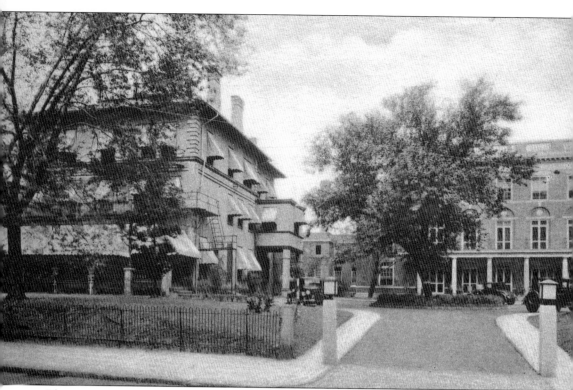

The West Philadelphia Hospital for Women, located at 4035 Parrish Street, is shown c. 1916. The first hospital building, dating from 1889, is on the left. In 1915, a three-story Georgian Revival–style hospital building designed by architect Walter Smedley was built. Two 19th-century houses at each end of the block were left standing as nurses' quarters. The hospital was enlarged again in 1931. When the hospital closed its doors, the building became the Sarah Allen Nursing Home, named in honor of the wife of Rev. Richard Allen, founder of the African Methodist Episcopal Church in Philadelphia. Unfortunately, by the 1960s, all the buildings were derelict and vandalized. In 1998, these historic buildings were restored as housing for the elderly by the Society of Friends and the U.S. Department of Housing and Urban Development. The buildings are now called Sarah Allen Senior Housing.

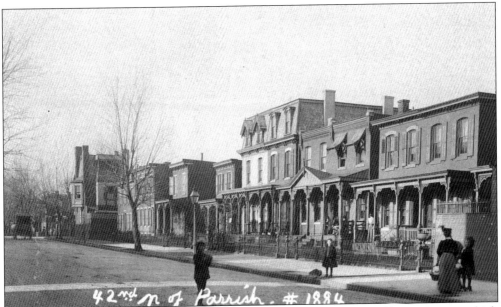

This 1908 view shows 42nd Street north of Parrish Street. The variety of house designs, which include Italianate and mansard, indicates that this block was built *c.* 1880. The mother and child shown carrying their shopping home in two wicker baskets is how everyday shopping was done at the turn of the century. The block is still standing.

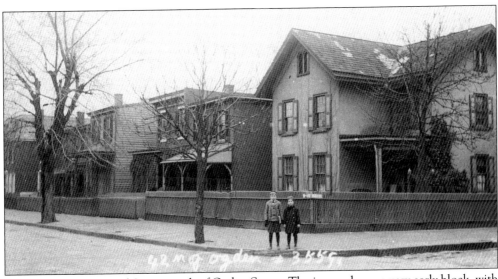

Pictured *c.* 1908 is 42nd Street north of Ogden Street. The image shows a very early block, with some wooden houses dating from before 1854, when Belmont was consolidated into the city of Philadelphia. The block had the appearance of a quaint village with wooden fences instead of wrought-iron fencing. By 1900, this old area of Belmont was soon surrounded by blocks of three-story row houses. Only the corner house stands today.

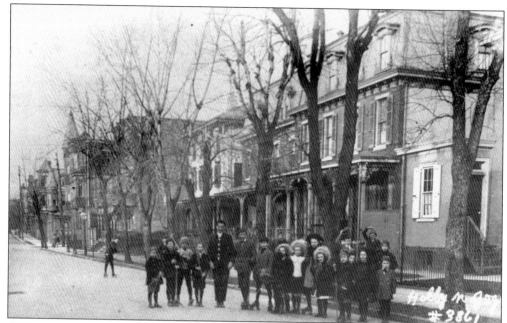

On an overcast February day in 1908, Mercantile Studio sent a photographer out to photograph Holly Street north of Ogden Street. The photographer took pictures of both sides of the street, and the local children followed him around as he set up his tripod and camera. Holly Street, with its gas street lamps, brick sidewalks, trees, and mixed styles of houses, had a small-town appearance that gave the Belmont area its unique character. The architectural styles of the houses varied from the earliest Italianate style from the 1860s, the Second Empire style with mansard roofs from the 1870s, and the simpler brick row houses built in the 1890s. Whatever the style, all the houses had to have a front porch. (Courtesy Dennis Lebofsky.)

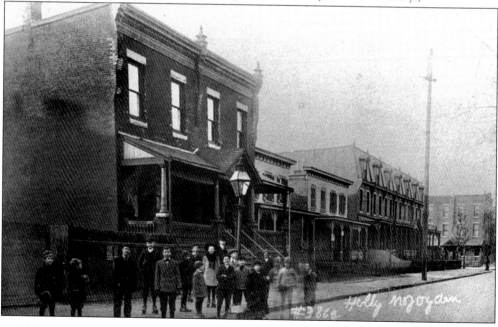

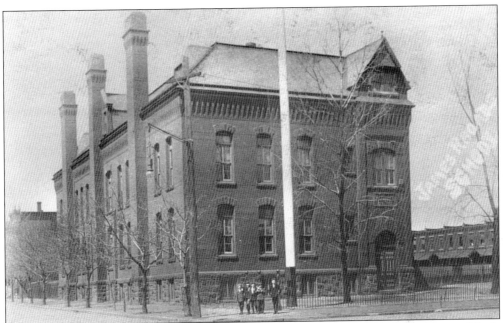

This 1908 view shows the James Rhodes School, located at 49th and Parrish Streets and built in the late 1880s. This rather formidable Queen Anne–style building had three huge chimneys, indicating that each classroom was probably heated by coal-burning stoves. A modern James Rhodes School sits on this site today. (Courtesy Dennis Lebofsky.)

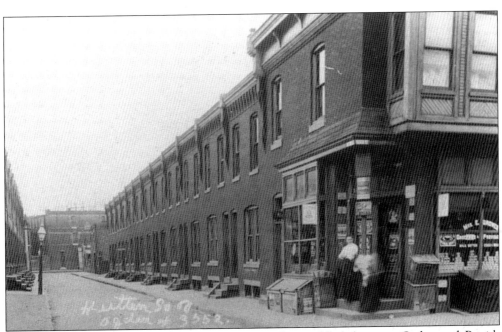

Shown in 1908 is Hutton Street, which ran for only one block between Ogden and Parrish Streets, west of 42nd Street. The block had the narrowest row houses in Belmont, only 14 feet wide. However, the residents still took pride in their homes, as evidenced by the cleanliness of the street. On the corner was Mrs. E. Groves's Groceries and Provisions. (Courtesy Dennis Lebofsky.)

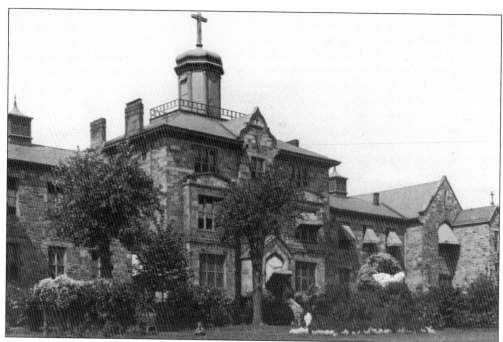

In order to establish a new parish in West Philadelphia, Bishop Francis Patrick Kendrick purchased 50 acres of farmland south of Lancaster Avenue in 1849 to build Catholic institutions. St. John's Orphan Asylum for boys, shown above *c.* 1910, was one of them. Built before 1872, it was located at 49th and Wyalusing Streets near Our Mother of Sorrows Church and across from Cathedral Cemetery. Orphanages were important faith-based institutions at the turn of the century, and West Philadelphia had more than its share of them. The postcard view below shows a group of young boys playing on the lawn area of the St. John's Orphanage under the watchful eyes of a group of nuns. The building is no longer standing today. (Courtesy Dennis Lebofsky.)

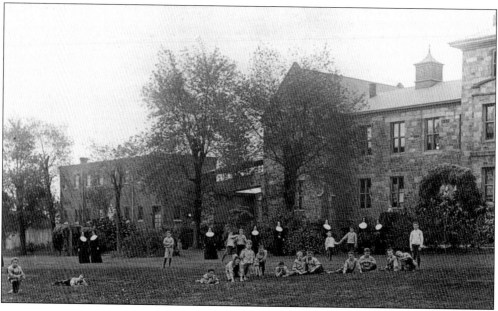

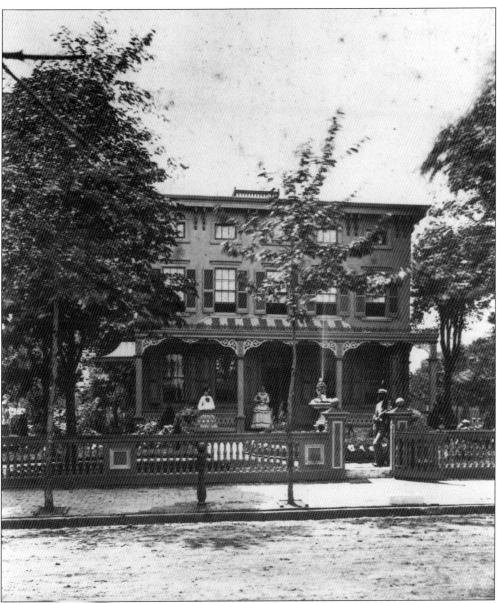

This 1870 picture, taken by photographer Robert Newell, shows the Italianate villa of Thomas A. Andrews, once located on the west side of North 41st Street between Ogden Street and Westminster Avenue. The villa had a striped painted-metal roof on the porch that was meant to look like an awning and an elaborate two-tone wooden garden fence. The house was a fine example of the village atmosphere of pre-centennial Belmont that once existed on Preston, Parrish, Ogden, and 41st Streets. The house was torn down in the 1890s, and the land was developed into six row houses. The Andrews family also owned several other properties on North 41st Street, all of which were developed as row houses in the late 1890s. As the neighborhood began to develop, Calvary Evangelical Lutheran Church (designed by architect Isaac Pursell) and the Pennsylvania Railroad's YMCA building were both built in 1892. They were located one block north at 41st Street and Westminster Avenue. (Courtesy the Library Company of Philadelphia.)

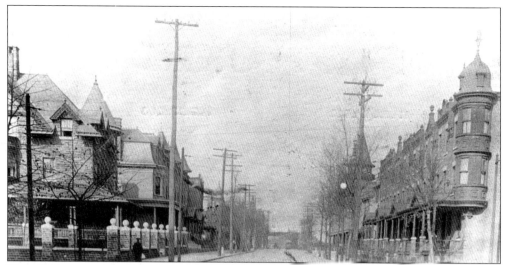

This 1908 image shows 41st Street north of Ogden Street. On the west side of the block once stood the suburban villa of Thomas A. Andrews. Built in the 1860s, it was replaced in the 1890s with a row of six houses, seen on the left. Also pictured is the French Chateau mansion of Allen B. Rorke, surrounded with a magnificent stone-and-iron fence. (Courtesy Dennis Lebofsky.)

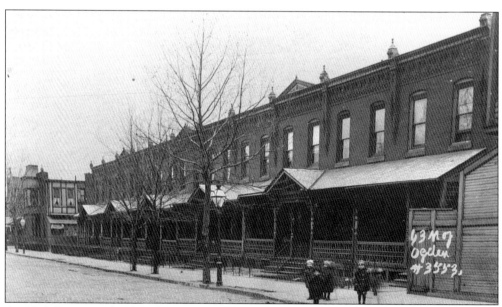

At 43rd Street north of Ogden were more modest row houses, typical of the generic West Philadelphia row house of the 1890s. As one moves west in the Belmont area, this style of house becomes more prevalent. This Mercantile Studio postcard was made c. 1908. (Courtesy Dennis Lebofsky.)

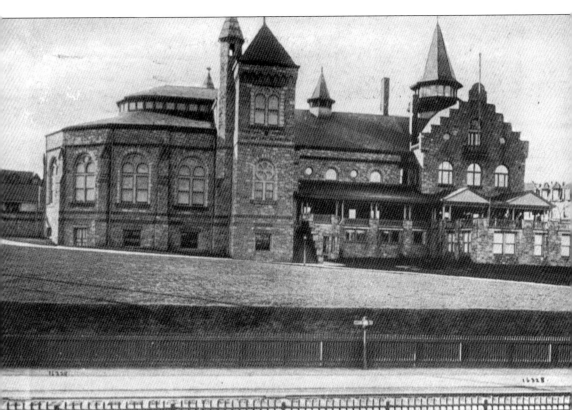

In 1892, architect Thomas Lonsdale (better known for his design of the Baptist temple on North Broad Street) designed the Pennsylvania Railroad YMCA at 41st and Westminster Streets. Lonsdale enlarged the building in 1896, adding a rounded auditorium, which totaled the construction cost at over $100,000, a substantial sum in 1896. The Gothic-style building had a large auditorium with a stage, a gymnasium, library, reading rooms, baths, dining rooms, social parlors, porches, and classrooms. There was also the 40th Street train station on the building's grounds. At one time, several hundred railroad men used the facility on a daily basis. By the 1940s, however, the building was abandoned and derelict. In 1943, Father Divine's Peace Mission bought the building and, at great expense, restored it as the Unity Mission Church, again making it available for use by the neighborhood children. Thanks to the Peace Mission, the building still stands today. This postcard view is from 1913.

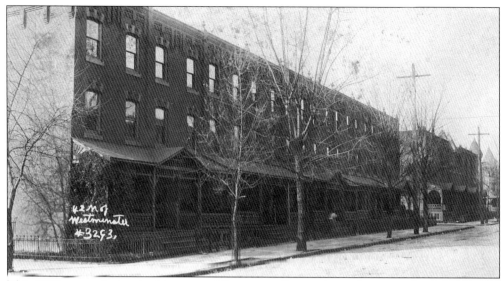

This 1908 postcard view, looking toward Penngrove Street, shows the west side of 42nd Street north from Westminster Avenue. The row, like many others in the neighborhood, was built c. 1895 when the electric trolleys began to run on 41st Street, connecting Belmont and Parkside with Center City.

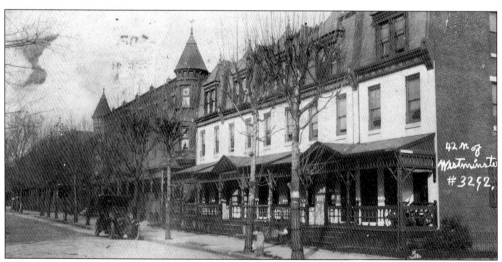

This 1908 postcard view is looking north from Westminster Avenue at the east side of 42nd Street. The block had two house designs; the six houses in the foreground were built earlier than the rest of the block, which has turrets at its corners. In 1908, a middle-class-income worker would have had to work 4,696 hours to earn enough to buy the automobile shown parked on 42nd Street.

Six

PARKSIDE-GIRARD

Before the 1876 Philadelphia Centennial Exposition in Fairmount Park, the neighborhood of Parkside-Girard did not exist. The Girard Avenue Bridge was not opened until July 1874. Near present-day 38th and Poplar Streets was a rather notorious isolated shantytown called Lainganville. When the exposition opened, things began to change. Elm Avenue (now Parkside) and Belmont Avenue were now lined with new hotels and restaurants. When the exposition closed in November 1876, some 10,164,000 people had passed through its gates, almost 20 percent of the national population. The temporary exhibit buildings were torn down, leaving Memorial Hall and Horticultural Hall standing. The temporary buildings on Elm Avenue were also demolished, and the Parkside-Girard area was now ripe for development. This was spurred on in 1895 by the new No. 40 electric trolley line that now ran to 41st Street and Parkside Avenue.

Almost the entire area was bought up by German brewers like Frederick Poth and Joseph Schmidt. Development organizations were formed (including the Blockwood Improvement Company and the Algonquin Improvement Company) that hired architects who favored the latest continental styles derived from Dutch and German designs. These favored architects of the German community were Willis Hale, Angus Wade, John Worthington, and H.E. Flower. They designed imposing houses and apartments on Parkside and Girard Avenues. Although these architects all had active architectural practices, they were not patronized by Philadelphia old society.

After 1900, the Parkside-Girard neighborhood began to change ethnically from those of German descent to Jewish emigrants from eastern Europe. The affordable housing and the neighborhood's connection by streetcar with South Street promoted Jewish settlement in the Parkside-Girard area. In 1907, the first synagogue, one of many to be built in the Parkside-Girard area, was opened at 3940 Girard Avenue, in what was the former Pennsylvania Bicycle Club's building.

In 1914, a silent-movie theater, the Ritz Theater, opened at 1106–1108 North 40th Street. The Grant Theater opened in 1922 at 4024 Girard Avenue. The Grant was built on the site of the Parkside Baptist Missions; ironically, the Grant Theater is now a church. Fortieth Street and Girard Avenue were thriving shopping streets, with two theaters, numerous restaurants and delicatessens, and stores that sold every type of food from "a chicken" to Zeidener's bagels. Parkside-Girard's Jewish community is still remembered fondly by many former residents.

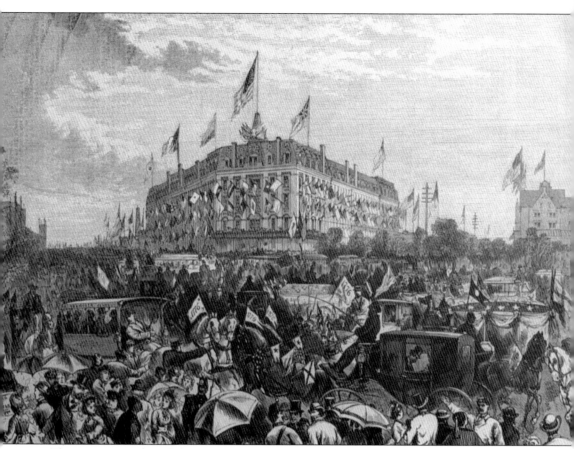

This is opening day of the Philadelphia Centennial Exposition in 1876 as seen in *Harper's Weekly*. The industrial world came to the intersection of Belmont and Elm (Parkside) Avenue to see the wonders of the machine age in the greatest industrial city in America, Philadelphia. At the corner of Elm and Belmont was the Trans Continental Hotel; to the right on Belmont Avenue was the Globe Hotel. After the exposition closed, all these hotels were torn down, except for one—the United States Hotel, which was still standing into the 1970s on the west side of 42nd Street between Leidy Avenue and Viola Street. The streetcar depot built for the centennial on a triangle of land bounded by Belmont Avenue, Thompson Street, and Leidy Avenue remained standing until 1962, when the new Leidy School was built on the site.

Memorial Hall served as Philadelphia's Art Museum until 1926. It was located on North Concourse Drive and was built as a permanent structure for the 1876 Philadelphia Centennial Exposition. Its architect was German-born Hermann Schwarzmann, who traveled to Vienna to study the 1873 Worlds Exposition. Memorial Hall's classical Palladian design was published in Germany and is said to have influenced the 1882 design of Berlin's Reichstag Building.

Smith Memorial, Fairmount Park, Philadelphia, Pa.

The incomplete Smith Civil War Memorial on North Concourse Drive is shown here in a foldout panoramic mail card made in 1904. Richard Smith gave the city a $500,000 for the monument's construction. In 1897, a competition was held for its design. There were 59 entries, and it was won by architect John Windrim. The final equestrian sculptures were placed on the monument in 1912.

This 1906 postcard is of the Fairmount Park Transportation Company's open trolley at the Strawberry Mansion Station, at 33rd and Dauphin Streets. The trolley ran through the park to the Woodside Amusement Park in West Fairmont Park. There was also a Parkside Station located on the northwest corner of Belmont and Parkside Avenue. The trolleys began running in 1896 and ended service in 1946; Woodside Park closed in the 1950s.

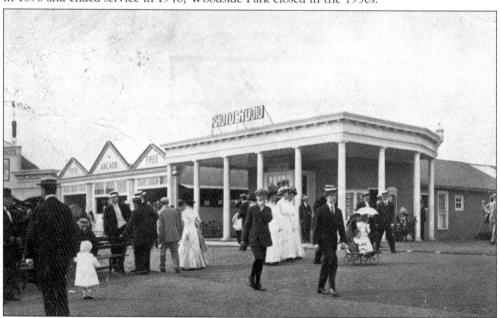

This 1911 postcard of Woodside Amusement Park was made by J. McLauchlan, whose photographic studio is seen in this view. Park patrons enjoyed a beautiful ride on the open trolley, perfumed by wild honeysuckle as they traveled through Fairmont Park to get to Woodside. At Woodside Park, they could enjoy the arcades, mechanical horse racing, a Bump the Bump slide, a lake for boating, and an old-time carousel.

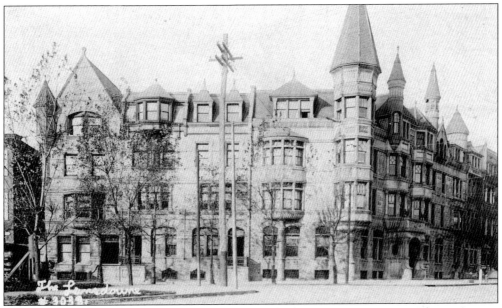

These 1910 Mercantile Studio postcard views show the Lansdowne Apartments, located across from the entrance to Fairmount Park at 41st Street and Parkside Avenue. The Lansdowne Apartments and adjoining row houses were designed in 1893 by architect John C. Worthington. They were the first new construction on Parkside Avenue after the centennial of 1876 and were designed as a Queen Anne–style ensemble, faced in limestone with decorative carvings, bay windows, and elaborate sheet-metal turrets. Worthington's style was picturesque and exuberant; he wanted to make sure those who got off the streetcars at 41st Street and Parkside Avenue noticed his extravagant design, with its tall pointed turrets. The Lansdowne building stands today, without its turrets and minarets. The three row houses on the left in the view above were torn down in the 1970s.

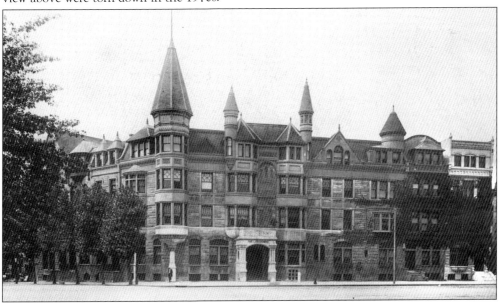

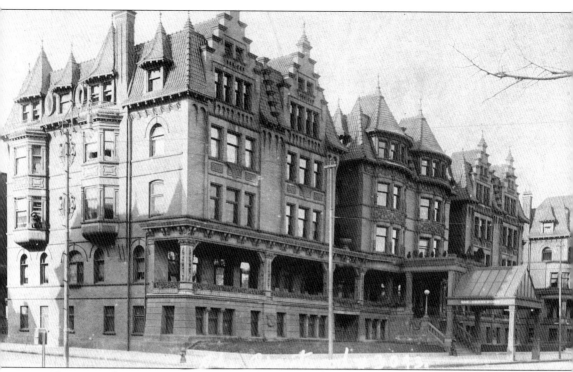

This view shows the once elegant Brantwood apartment building, on the 4200 block of Parkside Avenue, as it looked in 1908. It was originally built in 1897 as six very large twin houses. Along the entire building's facade, the architect, H.E. Flower, used decorative terra-cotta ornament and Roman brickwork. He designed raised porches facing Fairmount Park, giving the residents a great view of the park and its promenade drives. For financial reasons, the developer Frederick Poth decided c. 1900 to convert the six houses into one apartment building, connecting them with the addition of two elevator-stair towers and an entrance canopy. In 1974, after several fires, the building was derelict and was going to be demolished by the City of Philadelphia. The Brantwood was saved through the efforts of Dr. Laurence Henry (pastor of nearby Christ Community Baptist Church), architect Robert Skaler, and others who volunteered their expertise. Henry recognized the historic significance of the Parkside neighborhood years before there was a tax credit for restoring historic structures. The Brantwood, now restored, is on the National Register of Historic Places.

This is an 1899 view of the Parkside Apartments at 40th Street and Parkside Avenue. The building was designed by architect Angus Wade in 1897. It was an unusual design for Angus Wade, a departure from his more florid Queen Anne style. In 1897, the Parkside was one of the tallest apartment houses in Philadelphia. Unfortunately, by the 1970s, the building was a burned-out shell and had to be demolished.

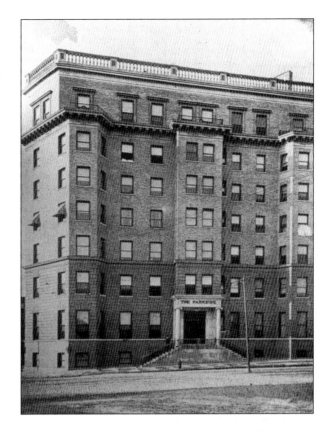

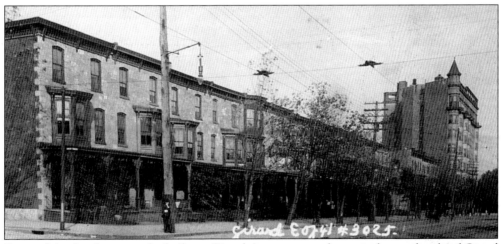

Some of the first houses to be built on Girard Avenue were those on the north side of Girard Avenue east of 41st Street. The row was in built in the Italianate style and faced with green serpentine stone, which was very fashionable in the 1880s. The Parkside Apartments (above) at the 40th Street end of the block is also seen in this 1907 image.

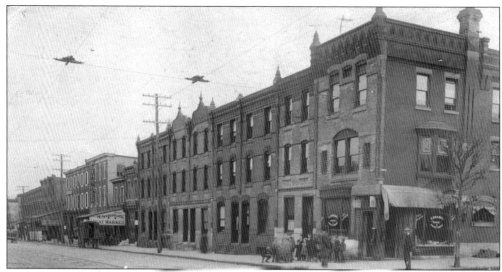

The south side of the 4000 block of Girard Avenue is shown c. 1907. On the corner at 41st Street was Greibel's Bakery. Alongside the Acme Tea Company and Steirlen's Meats was the Parkside Baptist Mission, founded by the Mantua Baptist Church. By the end of World War I, storefronts were added to all the houses on this block, as well as many on North 40th Street.

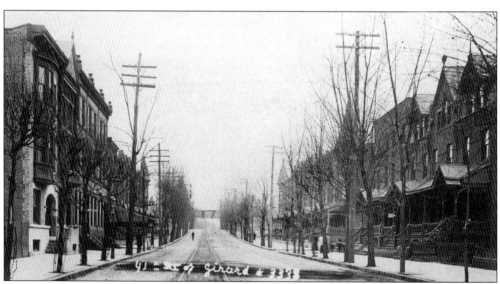

This 1907 postcard view is of 41st Street south from Girard Avenue, just around the corner from Greibel's Bakery, shown above. The spacious rows of three-story houses were built in the 1890s as the electric trolley car line extended north. The 41st Street Bridge, shown at the end of the street, went over the Pennsylvania Railroad tracks to the neighborhood of Belmont. Many of these houses are no longer standing.

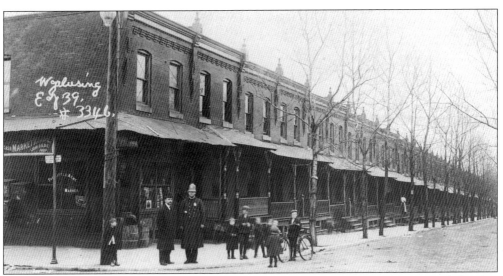

In 1908, these modest houses were the homes of new immigrant east European Jewish families who settled in Parkside-Girard area. Above is a 1908 Mercantile Studio postcard view of the northeast corner of 39th Street and Wyalusing Avenue. This block had 72 row houses, each one only 15 feet wide. The row houses were typical of workers' houses built *c.* 1900. Standing in front of the Little Acme Market was the cop-on-the-beat, who probably knew the nearby children by name. The view below, looking east, shows 39th and Poplar Streets. The two boys with the bike are in front of the corner store that was once a bakery. Poplar Street, like Wyalusing Avenue, was a very long block with many small row homes.

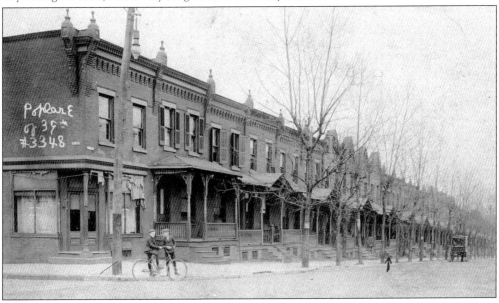

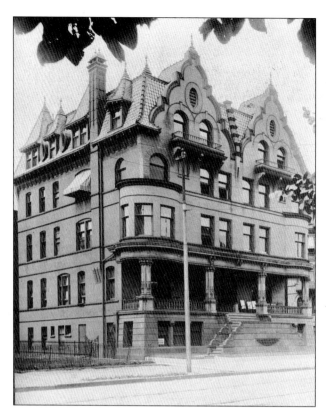

This 1907 view shows the Marlton Apartments, at Marlton and Parkside Avenues. The Marlton, built in 1897, was designed by architect H.E. Flower for brewer Frederick Poth. Flower used the same florid style for these apartments as he did for the other buildings he designed on the 4200 block of Parkside Avenue for Poth. He also designed the rows of houses on nearby Marlton and Memorial Avenues.

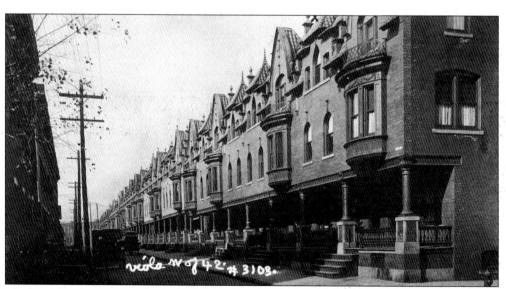

The 4200 block of Viola Street was designed by architect H.E. Flower with a unique floor plan. The houses had a common interior light well between adjoining houses that provided light for a grand center stairways in each house. It worked beautifully for a single-family home but not for multifamily use. Consequently, Flower's light-well design became a landlord's nightmare, leading to the abandonment of many these houses.

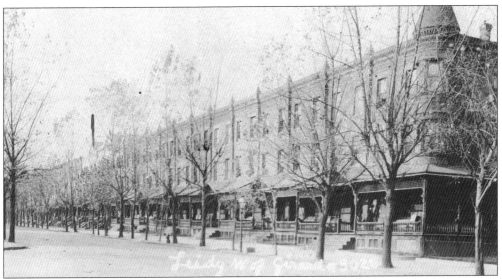

This is the northeast corner of Leidy and Girard Avenues as it looked in 1907. The postcard sender marked his house with a line. This long row of 46 houses was built c. 1892. The houses were only 16 feet wide but sat on lots that were unusually deep, running back 160 feet to Viola Street. A block away on Thompson Street was the old Joseph Leidy Elementary School.

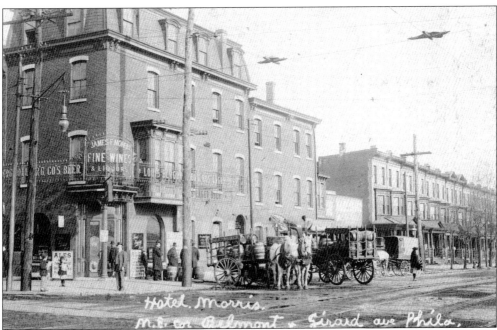

This 1908 postcard view shows the Hotel Morris, owned by James F. Morris. It also had a bar on the ground floor. It was located on the northeast corner of Belmont and Girard Avenues. In 1908, this was the western edge of the Parkside-Girard neighborhood. Across from this hotel, on Belmont Avenue, were coal yards, icehouses, and the tracks of the Pennsylvania Railroad.

Acknowledgments

As befits a book based on the development of West Philadelphia's streetcar neighborhoods, I would like to quote the Tennessee Williams play *Streetcar Named Desire:* "I have always depended on the kindness of strangers." This book could not have been written without the kindness of both friends and strangers who share my interest in Philadelphia history. They include fellow postcard collectors Howard Watson and Dennis Lebofsky, who lent postcards from their collections for this book; University City Historical Society members Tim Woods and Don Caskey; the Library Company of Philadelphia; archivist Bruce Laverty of the Philadelphia Athenaeum; Mark Lloyd of the University of Pennsylvania Archives; streetcar historian Joel Spivak; architectural historian Jeffery Cohen; and University City's longtime resident, poet, and historian Ruth Molloy.

A special thanks goes to David Rowland (president of the Old York Road Historical Society), historian Allen Meyers, Andrew Herman, Jose A. Rodriguez, and noted author and fellow University of Pennsylvania classmate Lynda Gureasko Yang for their encouragement and support. In addition, a special thanks goes to the West Philadelphia Partnership for permission to use excerpts from Leon Rosenthal's *A History of Philadelphia's University City.*

Images of rural West Philadelphia are very rare. This farmyard scene was photographed *c.* 1906 at 56th Street and Lancaster Avenue near present-day Overbrook High School. The sender of this photo postcard wrote that the farm was located on a "lane connecting Montgomery Pike with Lancaster Pike." The farm may have been one of the last vestiges of rural West Philadelphia remaining at that time east of 56th Street.